CORNFORD & CROSS

CORNFORD & CROSS

Essays by
John Roberts
Rachel Withers

black dog
publishing
london uk

'Open day'
M20 motorway, Kent, England, 1991

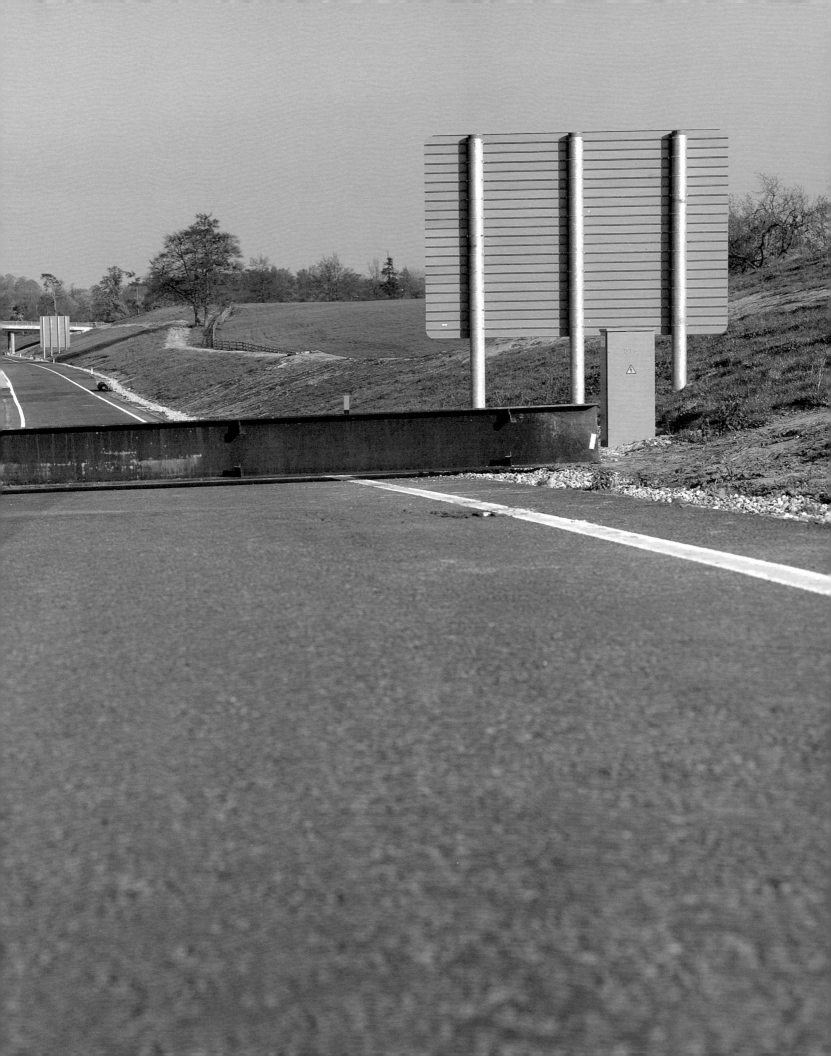

First published in 2009
Black Dog Publishing Limited
10a Acton Street
London WC1X 9NG
t. +44 (0)207 713 5097
f. +44 (0)207 713 8682
e. info@blackdogonline.com

All photographs by Cornford & Cross unless otherwise stated
www.cornfordandcross.com

Designed and edited by Cornford & Cross
Typographic consultancy O-SB Design
Proofread by Wendy Toole

Digital Prepress by Visual Aspects, London
Printed on Garda Pat 13 Kiara, acid free and FSC certified by the
international certification body Woodmark Soil Association 2006

British Library Cataloguing-in-Publication Data.
A catalogue record for this book is available from the British Library.
ISBN: 978 1 9061550 69 8

Cover image:
Detail from *The End of History*, 2004
Photograph of the site of the First Opium War
Pearl River Delta, Guangdong Province, China

architecture art design
fashion history photography
theory and things

www.blackdogonline.com

Contents

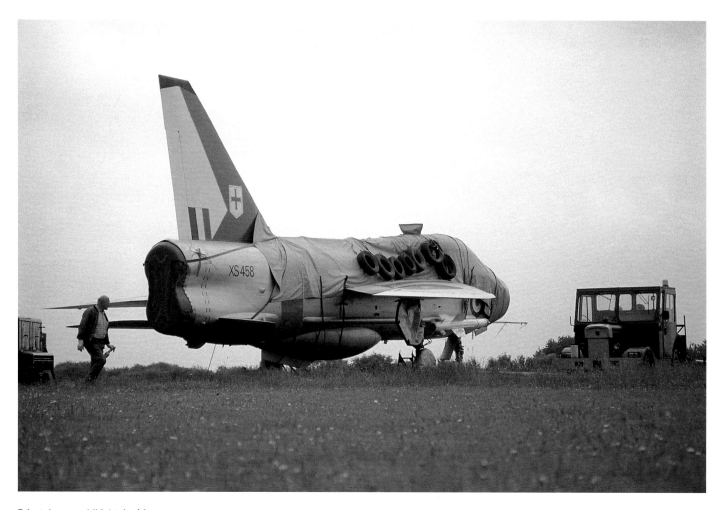

Privately owned 'Lightning' jet
Cranfield air base, Bedfordshire, England, 2000

Foreword

Alistair Robinson

The managerial and political lexicon of the last decade, at least in the English-speaking world, has been freighted with a peculiar combination of combative and creative metaphors. In parliamentary democracies, 'tough choices' have to be made. Governmental policy makers are asked to 'think the unthinkable', while middle managers indulge in 'blue skies thinking'.

Cornford & Cross' collaborative work of the same period has seemed to ask a number of questions. What if these 'tough choices' were openly discussed? What if they were not only faced up to, but brought vividly to life in public? And what if, while negotiating Byzantine planning procedures, bureaucratic committees and political timidity, visual artists working both in and outside the gallery did 'think the unthinkable'? What would works of art be like if, rather than thinking of more affirmative and bluer skies, artists were to intervene in public discourse and make manifest their analyses of our wider social structures?

No two projects by Cornford & Cross are alike. Each work is an adventure for both audience and artists. No preconceptions can be brought to a new work; no simple resolutions are offered; no position is left comfortable or unexposed. The artists' card once read: "Cornford & Cross: Problems Solved". Rather, their contribution to contemporary art has been to locate, with an alarming accuracy, the contradictions and problems upon which our collective definitions of 'culture' are founded.

While the artists have successfully brought a substantial body of works to fruition outside the gallery, the relationship between these and their 'unrealised' projects deserves wider attention. On several occasions the artists have found the limits of what is expressible in public. In *This England,* for example, their proposal to build a stretch of concrete motorway flyover in Green Park, London, threatened to rudely interrupt the manicured *rus in urbe* that adjoins the head of state's official residence, and the tourist centre of the capital. This adversarial intervention, in resembling

high modernist monuments such as Victor Pasmore's Peterlee pavilion, offers pathos as much as consternation or comedy. Other works have approached points of contention through more oblique strategies, or even achieved lyrical results. *Utopia*, for example, is another 'urban improvement': the meticulous renovation of a dilapidated pond and fountain in Bournville, the estate where Cadbury factory workers still live and work. Cornford & Cross' civic spiritedness echoes the philanthropism – if not quite the paternalism – of the Cadbury dynasty.

In the last decade, it has often appeared that 'consensus art', as Andrew Brighton has described it, commands the marketplace, museum collections and media attention. Cornford & Cross' more contrariant strategies are, by contrast, a reminder of artists' abilities to shift the boundaries of what art is able to be, what it is capable of, and whom it can address.

Alistair Robinson is Programme Director for the Northern Gallery for Contemporary Art, Sunderland, England.

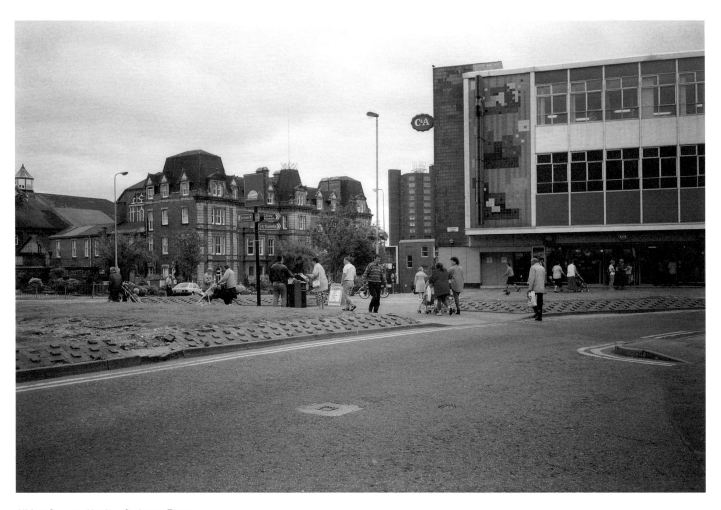

Albion Square, Hanley, Stoke-on-Trent,
England, 1996

Fade Out

John Roberts

"The dead brood under Britain. We whisper. We echo. The emanation of Giant Albion."

David Peace, *GB84*, 2004

Cornford & Cross are public artists, indefatigably so. They work collaboratively in public, usually with various artistic and non-artistic constituencies and audiences, in ways similar to those of many public artists before them. But they are not public artists as most commonly accepted or understood, certainly in the light of Conceptual art, situational aesthetics (Hans Haacke and Michael Asher) and the whole gamut of 1980s work indebted to institutional critique. This is because there is a troubling self-negation, or self-ironisation, to what they do, which seems to derive from their acceptance of the very implausibility of the category of public art itself and of their role as erstwhile public artists. They may work collaboratively, they may be proud to have no studio, and they may be committed to the most strenuous research and preparation, but they also offer no model of 'good practice', beyond a basic commitment to conversation with those interested parties whom they approach. However, this does not mean Cornford & Cross act in bad faith as artists, or are incorrigible cynics, but rather that their art operates deliberately, and sometimes provocatively, as a kind of faded after-effect of art's public authority. In this sense their work is functionally self-disabling for a good reason — as a way of holding on to a sense of their own autonomy as artists in the face of what might be called the gross social impertinence of public art's claims.

This self-disablement is reflected in the mute or bathetic character of many of their interventions or structures. Disinterested in returning the pleasurable gaze of the spectator, the art seems unable to bear the weight of its own critical reason. It is as if the only way of truly honouring the display of their art outside of the art institution in a hostile world is to render it unprepossessing, or self-forgetful as art, as something you might mistake for something else; for in being mistaken for something else, it seems to hint

at the possibility that another kind of conversation might begin, a conversation in which art and the social world might exchange more than passing glances. This is exemplified by one of their best works from the 1990s and one of the most socially vivid works produced in Britain during this period: the installation *Camelot*, 1996. *Camelot* consists of three neglected islands of scrubby grass ringed off with ten-foot palisade steel security fencing in the centre of Stoke-on-Trent. Simultaneously banal, engrossingly enigmatic, and impressively authoritarian, the rings of steel generated a local furore, as people accused the artists and/or the local council (who supported the work) of variously wasting money, being culturally arrogant, and displaying political insensitivity. What right had the council, in collusion with artists, to fence off common ground? But, in asking the question, in fielding the anger and the rightful scorn of others, Cornford & Cross got their artwork made and generated a conversation. Where are the commons today? Who controls access to them? Why is so much public space under the glare of private inspection and control? Thus, through a work of the barest of means, indeed in a work that had the lowest of thresholds of 'artisticness', a whole set of arguments about the ownership of space, of public access, tumbled out. By endorsing what appeared to be an arbitrary act of power, Cornford & Cross transformed a given locale into a site of productive conflict and tension. The mutedness of their art, then, is deceptive. For once the work enters debate its 'disinterestedness' becomes a trigger for popular forms of dissent and the exercise of collective memory, and, as such, as it is possessed and 'remade' in the interests of others, it is able to expand far beyond the authors' intentions and expectations.

But if critical heat is generated, opinions polled, prejudices aired, *Camelot* remains in the end a work of art and not an anthropological field survey or an experiment in cognitive psychology. This is because its self-disablement as public art also brings with it the detemporalising effects of aesthetic experience. *Camelot* may deny certain customary expectations and clues of art, even situational art, but it

cannot prevent its social character taking on a significant symbolic form and, therefore, a certain poignancy.

Indeed, it is this air of poignancy born of self-ironisation that unites much of their work, giving their self-disablement as public artists a particular historical and national inflection. For Cornford & Cross are first and foremost travellers through, and historians of, post-1980s English culture and the English landscape. Since the mid 1990s Cornford & Cross have produced a body of public work in which the characteristics of regional place, the symbols of the English national tradition and the environmental effects of post-Thatcherite capitalism intersect. Indeed, it is precisely the unity of place, national tradition and the advance of neo-liberalism that provides the material and symbolic furniture for their triggering of 'collective memories'. This gives their art an explicit diachronic dimension, in which self-images of national identity and memories of the recent past connect to form a social and historical narrative. And this narrative, specifically, is that of England and Britain after the Great Miners' Strike, after so-called de-industrialisation, after the privatisation of the public sphere and the destruction of what can be seen now to be the symbols and memory of indigenous traditions of labour.

In the 1980s, during Thatcher's first term in office and in the wake of the defeat of the miners in 1985, many historians and cultural theorists turned their attention to the formation of the English and British national tradition.[1] What preoccupied these writers was the way in which the Tories in power were quite willing to use Britain's imperialist legacy in order to distinguish their neo-liberal project from the anti-patriotic multi-culturalism of socialistic state institutions and state provisions. For a number of these historians, the Falklands War was crucial to this ideological mobilisation. Britain's victory in the Malvinas not only reasserted Britain's (faded) imperial prerogatives, but reaffirmed the Conservative Party as the natural party of national leadership.[2] One writer, Patrick Wright, saw this as part of a broader conservative counter-revolution in which images of Britain's imperial

and conservative national past were taken out of mothballs in order to re-enchant a pre-modernist British past. In *On Living in an Old Country*, 1985, Wright describes Britain at the time as a floating museum.[3] This was the period of the revival of the National Trust and the Society for the Protection of Ancient Buildings, and the development of the concept of National Heritage, as conservative forces struggled to impose their *retardataire* agenda on the recent past. In many ways they were successful; the displacement or eradication of the symbols, monuments and traditions of Labour and radical Britain has remained in place, as New Labour through the 1990s has extended the Tories' neo-liberal project. London, for instance, is not just a floating museum, but a floating museum of inoculated imperialist trumpery, in which, in some Whiggish fantasy, the 'enlightened' New Labour state is a home to the memory of all: slaves, aristocrats, big landowners, gouging industrialists and the victims of fascism. This is because in direct contrast to 80s Toryism – and this essentially defines the passage from Tory neo-liberalism to New Labour neo-liberalism, culturally, in the 1990s – the ideology of multi-culturalism has been wedged into the space of the National Heritage, in order to bring it into alignment with some notion of 'lived experience'. One of Wright's key arguments in the 1980s was that the conservative 'takeover' of the National Heritage was not in itself a disastrous thing. That is, following arguments that were influential in cultural studies, dominant cultural forms were not heteronomously structured or ideologically self-enclosed, and, therefore, were available for various counter-hegemonic readings. Indeed, all forms of cultural production could be described as being multi-accented, and therefore open to different readings. In the 1970s, cultural studies' development of the notion of the 'creative consumer' made something of a dogma of this, and Wright certainly followed in these footsteps – although his intellectual mentor was Agnes Heller rather than the new cultural studies itself. Thus, according to this model, forms of historical and critical consciousness might be brought to bear in the appreciation of the aristocratic high-cultural monuments of the National Heritage that could release

utopian or counter-hegemonic energies. For instance, there is nothing essentially conservative about walking around the grounds of Chatsworth House and acknowledging its beauty; on the contrary, its beauty provides a model of aesthetic organisation that establishes a profound reminder of how instrumental most building and urban development remains under modern market relations. And so on. Twenty years on, though, hopes for a counter-hegemonic re-reading of the National Heritage providing a public space for dissident or counter-histories have long gone, as a multi-cultural self-assertion fills up the available 'progressive' 'historical space'.

Cornford & Cross step into this post-Thatcherite national landscape, a world of deracinated public cultures, hystericised faith in markets, and bland and ahistorical multi-culturalisms. But instead of producing didactic counter-hegemonic interventions in defiance of this sense of order, they almost do the opposite — they 'hang around', so to speak, melding their interests with the interests and views of their interlocutors. This is not to say that they do not know what they are doing until they are involved in their collaborations, or that their first priority is to the interests and opinions of their interlocutors and collaborators in the manner of oral historians. But, rather, their sense of what it is to intervene in a given social context in order to produce a counter-symbolic form is determined by the dynamics, internal conflicts and contradictions, and local ideological colour of the setting they are working in. One of their primary methods therefore — not always successful — is to develop the work in ideological fluidity with the subjects of their concerns, without these subjects withdrawing or actually running away. Thus as 'public artists' they begin from the premise that they do not know best. But at the same time this is not a form of dialogism in which artists and collaborators set out to achieve some benighted mutual understanding. Rather, the notion of ideological fluidity hides a deeper practice of subterfuge and shadow play, in which the artists take back from their subjects something that their subjects cannot take back from them as artists: their critical percipience. As a power strategy this has its intellectual

origins partly in Socratic *maieutic*, the drawing out of unconscious knowledge in those without knowledge through extended dialogue; Cynic *metis*, the initial submission to an other or enemy, in the hope of turning the tables once the other person is off guard; and Michel de Certeau's practice of *la perruque* (meaning literally 'wig'), in which the forms, materials or modes of attention of the dominating are quietly and carefully used against them.[4] De Certeau gives the example of the lathe worker stealing time and materials from the labour process in order to produce something — a gift, a token — for herself or others. The worker has reasserted her autonomy by reinhabiting and reshaping these forms which dominate her labour. Thus, for example, in *Jerusalem*, 1999, the *perruque* — or ideological stalking horse — is the patriotic leaden statue of the boy soldier. Although the form of the work is clearly conservative, this conservatism is deceptive in relation to its setting. This is because the perceptibly conventional character of the project is, in fact, the lure that actually gets Cornford & Cross into the public school, King Edward VI Boys' School, in Norfolk, England, as official/unofficial artists. By entering into dialogue with the school's 'best interests', that is, by playing up to the school staff's sense of what is proper (aesthetic conservatism, national pride), the proper is imported into the improper with the school's tacit consent: it was agreed between Cornford & Cross and the school that the metal used in the statue would be taken from melted-down bullets — clearly giving a different kind of resonance to the completed statue.

This insinuative approach to dialogue would seem to be a highly fraught, highly attenuated and almost mystificatory way of going about producing a public and critical art. Who in the school or visiting the school would have been prepared to read the statue against the grain of its manifest aesthetic conservatism? For all the world the statue looked like any conservative war memorial that you could find in the grounds of any public school. But, in the final analysis, this 'failure' of the counter-reading *in situ* is not the point. For the failure to read the work counter-symbolically does not mean that

the work is unable to take its place some time later in a context not determined by its initial conditions of production. In fact, this is what happens to artworks, and in particular public artworks, all the time. Thus, if some of Cornford & Cross' works are very successful in generating counter-meanings *in situ* — such as *Camelot* — this does not imply that a work like *Jerusalem*, which establishes a restricted or clandestine relationship with its potential local audience, is any the less successful. On the contrary, it means that the ideological fluidity of the dialogue between themselves and their interlocutors and collaborators is always relational, and this relationality must be taken account of in any experience of the work. Importantly, then, this changes what we might mean by the term 'public' in public art. For there is no Public audience for their artworks at the work's point of reception, only publics/localised audiences. It is only retrospectively, when each work is placed syntagmatically in relation to preceding works, that the possibility of a Public over and above the formation of contingent publics emerges. The Public, therefore, is ultimately a historical and memorial category. This is why, in conjunction with their actual interventions, they place such an important emphasis on the photographic archive. Indeed, it is primarily through the continuous extension of the photographic reproduction of their projects that the diachronic content of their practice emerges and their prospective identity as 'historians' of the English landscape and British national culture coalesces.[5] I am writing this text never having seen any of their works *in situ*. I know their work only as photographic symbols, as textual memories, so to speak. This is not unusual in the history of twentieth century art. The meanings of certain practices can only be reconstructed from their virtual representation. One of the most important works of the twentieth century takes this virtual form: Duchamp's urinal — all we have is Alfred Stieglitz's photograph and a later replica. So, if the question of critical efficacy is not bound by the determinates of material space, this means that the issue of Public accessibility is a shibboleth. The concept of the Public is not a static thing fixed in time and space, but can enter into relationship with a work through different points of reception in many contexts in many futures. The function of their photographic documentation, therefore, is not to close off these possible future circuits of reception, but in a sense to provide a meta-point of interpretative 'closure' for these future forms of interpretation.

Nevertheless, this is not to say that Cornford & Cross are indifferent about giving material form to their interventions, or slow in responding to the demands of producing an audience at the point of reception of the work. Accepting that virtuality is part of the afterlife of a work of art is not the same as endorsing a virtual practice. On the contrary, the act of making something as a break in the continuum of the real remains important as a way of holding onto the possibility of art as praxis. As they insist: "We want to say: 'we were there, we did that'."[6] Thus, there is always a qualitative difference between the virtual and the actual, insofar as the virtual is condemned to follow the line of least resistance. All kinds of counter-symbolic meanings can be produced in perpetuity in virtual (digital) form, but because these meanings fail to establish a break or rupture in the actual, in metric space, their truth content remains confined to the realm of intellectual rather than sensuous practice.

But what kind of sensuous practice is it that follows a path of self-ironisation? If Cornford & Cross fear their instrumentalisation as public artists, why commit themselves to an arduous and compromised process of ideological insinuation? The answer to this lies in their relationship to the issue of art's negation in a world of art's social positivisation. To endorse public art as a process of dialogue with certain intractable material interests and processes in the world as the basis for the transformation of part of the world in the name of art, is to insist that art must risk its own failure if its sensuousness is not to emerge as a form of empty affirmation. In this sense Cornford & Cross' work pursues a strange, but necessary, paradox: they fight assiduously and tenaciously to create works that exist as ghostly things, deflationary gestures, faded after-effects, bathetic monuments, self-negligent

objects, inert signs. Because in actually positioning their installations/objects in the world of non-artistic things, and making some of their objects take the form of many of these non-artistic things, their strategies of artistic self-disablement are able, albeit temporarily, to drain this object-world of its positivity. This is particularly striking in *New Holland*, 1997, produced at the height of club culture and New Labour paeans to Brit Art in the 1990s. This work consists of a large steel barn-like structure without windows or any kind of apertures. From inside the viewer can hear the repetitive beats of House music. As in *Camelot,* the art's formal intractability produces a heightened sense of the work's non-relationality. There is no point where aesthetic judgement might reclaim the work from its own dismal indifference to the spectator. Yet as in *Camelot*, it produces a moment of vivid historical consciousness out of its formal intractability and anti-aestheticism. The work's featureless Minimalist gloom and self-enclosure generates an experience of trapped or frustrated pleasure-seeking. That is, the desire to experience the music or, conversely, change or even stop the music cannot be acted on: it carries on, insistently, annoyingly, unconnected to any audience. The building and music, therefore, deny and entice the senses at the same time, creating a state of perpetual disappointment, as if the spectator's sense of discrepancy between the promise of pleasure and the cathecting of the object of desire was an allegorical reflection on the mass cultural subject itself. What does it take, then, for a work of art to perform this kind of failure? What notions of artistic identity and what conceptions of authorship are being engaged here?

The performing of failure — of various intellectual and cognitive skills, of the traditional artistic and moral virtues, and of self-identity — became, in the 1990s, a powerful way of reorientating how artists might be responsible to art as praxis, as self-negation, as opposed simply to the intertextual reordering of the generic categories of art: the problem postmodernism had become mired in. Numerous artists — male and female, but particularly male — explored notions of incompetence or the 'fall from knowledge' as a way of

returning art to knowledge with some critical, rather than simply academic, volition. Scrappy child-like drawings, badly made objects or badly taken photographs, unedited texts and the representation of submissive, passive or abject acts were commonplace. This produced a generation in which the exploration of formal knowledge in art, and the idea of the artist-intellectual, were, if not dismissed, subject to a sustained critical deflation. In the 1990s Cornford & Cross took a different path from this psychological self-profiling of the artist as faux-incompetent. It was the interdisciplinarity of Robert Smithson, rather than the 'pathetic art' of Bruce Nauman, that focused their ambitions. But, at the same time, they were not immune to the forms of performative self-ironisation of 90s art. Indeed, their tactics of self-disablement clearly operate within the broader framework of the art of the moment and recent past. After the critique of authorship, after the internalisation of the readymade as a technical category, and the general convergence between artistic skills and non-artistic practices and skills, art's relationship to skill and knowledge is no longer internally constrained or disciplined by the inherited categories of art — if ever it was, of course, in the twentieth century. In a world in which the skills of the artist converge with or mimic the de-skilled skills of non-artistic labour, what remains of specifically artistic skill (painting a landscape or biomorphic abstraction, drawing from life) is open to dispute. In the wake of the long history of the critique of authorship from Duchamp and Moholy-Nagy to Conceptual art, art has no less significant a relationship to non-artistic discourses and practices than it does to the genres of art. Art is neither more nor less than the execution of an ensemble of transferable intellectual and technical skills inseparable, at some points, from other kinds of skills. Artists, then, are neither more nor less than the decentred executors and bearers of these skills, rather than of any kind of 'expressive' unity, as in the Cartesian tradition.

Like other artists of their generation, therefore, Cornford & Cross operate in a space where the expanded circuits of authorship now have a real and determinate effect on how

artists see themselves as artists. The distribution of artistic skills into non-artistic skills and the distribution of non-artistic skills into artistic skills has shattered the unambiguous notion of the artist as creator tied to a given formal tradition. In many ways this had entered its final period of crisis with Robert Smithson. Smithson had little or no interest in what the inherited technical categories of painting and sculpture might provide for him as an artist. Yet at the same time his logistically complex interventions into the desert carried a strong sense that art might expand into the landscape and therefore into everyday sensuous practice. Since the mid 1970s, though, this available space, or the sense of this available space, has got narrower and narrower. The terms under which art might intervene in the external world have become subject to innumerable material and ideological constraints. Most of these constraints, of course, have simply to do with the protection of private property and the rule of law. Others, however, are imposed by the institutions of art and other cultural organisations in response to these prior restrictions and prohibitions. That is, the public space for public art is now highly mediated by what is considered to be appropriate or inappropriate, proper or improper, in any given area of the public domain. And artists, it is argued, should take this into consideration in the formulation of their ideas and proposals. In this sense a form of internal self-censorship posing as realism has emerged with, and has become the formal basis of, the growth of public art since the 1970s.[7] This is why many artists who learnt from the Smithson model in the 1970s turned in the 1980s to the placing of 'public work' inside the institution itself, where despite other kinds of ideological restrictions they were able to retain a degree of autonomy.

Cornford & Cross are part of a generation for whom the delimitation of the category of public art as praxis is a direct consequence of these forces. But rather than abandon the public domain outside the gallery they have chosen to use their strategies of *maieutic*, *metis* and *la perruque*, of feints and dodges, as a way of getting under the wire, so to speak. The self-ironisation, therefore, is something more than a

'fall from knowledge' in any simplistic sense. It is a way of making what is done in the name of public art generate something *more* than its good name. It's a way of returning art to its possible extra-institutional identity as a kind of social irritant, that – in fact – rejects the very idea of public art's good name. But by ironising the category of public art, they do not thereby dissolve its partisan claims for the social meaning of art. This is what makes their placement of ghostly symbolisations and inert signs and deflated monuments in the English landscape retain something of the Smithson legacy, at the point of separating from it. For at various points in the life of their temporary installations the ironic character of their circuits of authorship is itself ironised. Thus, after *Camelot* was dismantled, the palisade fences were given to a local school. Similarly, the barn in *New Holland* was given to a local farmer near Norwich to house his chickens. Both school and farmer were very grateful. This slightly embarrassing return of the materials of the art to their previous functionality is instructive. That is, Cornford & Cross' desire – once the work had been dismantled – to extend its circuit of authorship to include that of non-artistic practices introduces another level of critical displacement into the art, which, precisely because it cannot hold the high ground critically in their practice, becomes extremely interesting. What has stood in defiance of the social positivisation of art – an art of muteness and deflation – becomes, in its final 'fade out', no more than materials that the work had been made out of. I don't know whether this signifies anything wider about how Cornford & Cross see their relationship as artists to art's incorporation of non-artistic skills and materials. But it does point to a moment of reflection in their work on another kind of extra-institutional function for art: a social praxis in which the production of art objects is shared equally, by artist and non-artists alike. I'd like to think, then, at these points of return, that Cornford & Cross ironise their self-ironisation, not in order to make the art somehow amenable to direct political appropriation, but so that it is available as moments from a world where ironisation is not the only thing that keeps meaning open and alive.

John Roberts is Professor of Art and Aesthetics at the University of Wolverhampton. He is the author of *The Art of Interruption: Realism, Photography and the Everyday*, 1998, and *The Intangibilities of Form: Skill and Deskilling in Art After the Readymade*, 2007.

1. See for example Eric Hobsbawm and Terence Ranger, eds., *The Invention of Tradition*, Cambridge: Cambridge University Press, 1983.

2. See Anthony Barnett, *Iron Britannia: Why Parliament Waged its Falklands War*, London: Allison & Busby, 1982.

3. Patrick Wright, *On Living in an Old Country: The National Past in Contemporary Britain*, London: Verso, 1985. See also Tom Nairn's reading of the formation of conservative English nationalism, in *The Break Up of Britain*, London: Verso, 1982. For Nairn the virulence of conservative English nationalism has its origins in the fact that Romanticism did not serve as an instrument of national liberation. The popular nationalism of the early nineteenth century found its form in the patriotic counter-revolution against Napoleon.

4. Michel de Certeau, *The Practice of Everyday Life*, Berkeley, CA: University of California Press, 1984.

5. Their work achieves a counter-symbolic afterlife in the diachronic space of the photographic archive. All their projects cohere into a narrative and literary form through their careful and assiduous photographing of each of their installations.

6. Cornford & Cross interviewed by Henrik Schrat and Oliver Hartung, "The Picture as index of lived experience", *4:28*, no. 1, 2001, p. 11.

7. This is one of the reasons that Cornford & Cross have paid little heed in many of their funding applications to public art's customary realism. In *Coming up for Air*, they proposed to install a large cylindrical chimney stack in the middle of a reservoir in Chasewater Country Park, Staffordshire. In another project they proposed to build, to scale, a concrete flyover in Green Park, London. The impropriety of these projects is not idle brinkmanship, however, but a generalised risk strategy in which the candour and integrity of other — and more amenable — projects can be protected. The priority, therefore, is to the autonomy of the work-in-progress, even if it does not proceed beyond the drawing board, and not to the expectations of the funding body.

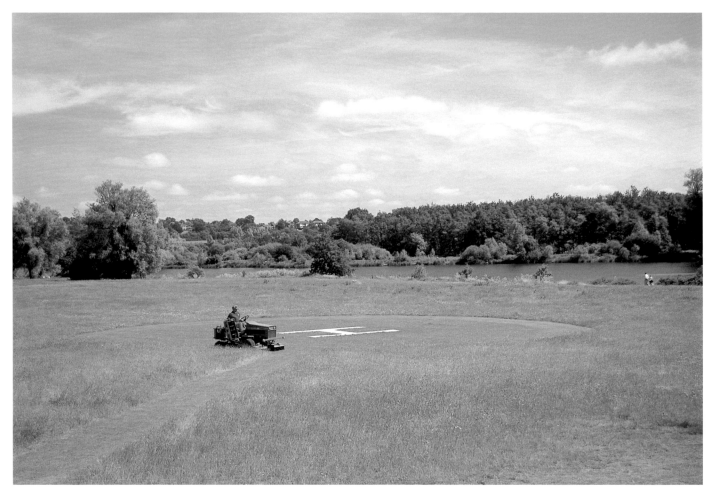

Helicopter landing pad
Sainsbury Centre for Visual Arts
University of East Anglia, England, 1997

Style and Character

Rachel Withers

I. Where is the Work?

"Cornford & Cross: Problems Solved" ran the text on a business card that the artists Cornford & Cross employed, in the late 1990s, to promote their practice. Comically vague and unmistakably self-ironising, the slogan clearly signalled that they were not, back then, in the business of solving problems. They still aren't; now as then, 'problems instituted' might seem nearer the mark. Take, for example, the question "Where is the Work?", as posed in the title of their 2004 project at the South London Gallery. Among the diversity of their activities, where does the art part of the artwork reside?

The pair's workload is indeed disparate: it involves making proposals, engaging with commissioning and competition processes, project-managing the construction of works, installing objects and images both within and outside the physical spaces of the art institution, documenting and promoting projects, and representing the practice to academic and non-academic audiences. Cornford & Cross point out that while many of their projects have been seen through to completion as concrete, publicly sited objects, others exist as unrealised proposals — documentary artefacts composed of photographs, texts, plans or models. They observe that audiences are more likely to encounter their completed projects, which are usually temporary, via documentation than 'live'. They point to the social interactions to which their projects give rise as another kind of outcome. They also suggest that the continuing success of their collaboration hinges, in part, on the recognition that their individual understandings of their various works do not always — or even often — exactly coincide, so it would be problematic to suggest that 'the work' ultimately rests on some core underlying concept underwriting each piece. A quick answer to the artists' question would be that 'the work' is manifested across this continuum of (sometimes contested) concepts and objects, processes, practices and exchanges, but this seems far too vague.

Obviously, this basic problem of definition relates not just to Cornford & Cross' work; it reflects the gamut of definitional complexities and uncertainties played out in the discourses of art from the early twentieth century to the present. Today (except in the commercial sphere, where even the most intangible, or 'conceptual' artwork is subjected to tight definition for the purposes of buying, selling and investment) a general, default assumption tends to underpin contemporary art discussions: that over and above objects, art is best understood in terms of practices — the generation of special, yet changing, modes of attention and special, yet changing, types of social interaction. For this and other reasons, it seems sensible to argue that there can't be a definitive overarching answer to the question "Where is the (art)work?". Nevertheless, it's not a rhetorical enquiry. Any critical approach to any artwork must necessarily formulate a contingent answer as regards the particular work, even if that answer remains implicit.

This essay will respond to Cornford & Cross' question by attempting to describe how their artworks operate as artworks, as distinct from social commentary, historical polemic or political activism. To do this, it proposes to look closely at the letter of the text — noting, for example, that Cornford & Cross seem to love skyscapes (some summery blue and scattered with benign fair-weather clouds, others stormy, others ignited by the sunset, and so on) and that their imagery returns time and again to canonical Western conceptions of the beautiful. By examining the visual and other details of particular works and exploring the ways in which the artists themselves articulate what they do, it will suggest how the works function as aesthetic artefacts.

As Terry Eagleton has noted of the term "aesthetic", "[f]or a notion which is supposed to signify a kind of functionlessness, few ideas can have served so many disparate functions" — so some clarification is evidently needed.[1] This account is specifically concerned with the

aesthetic effects of Cornford & Cross' style. Talk of style, blue skies and beauty might seem to presage a risky depoliticising of what is evidently a politically invested practice, but this is not the case. The term 'style' will here be allocated a broader and more pivotal meaning than art-historical conventions usually allow it, a tactic partially sanctioned by philosopher Carolyn Wilde, in her essay *Ethics and Aesthetics are One*. Wilde's text probes Ludwig Wittgenstein's proposition that "ethics and aesthetics are one and the same", and proposes that aesthetic style and ethical 'character' might be viewed as comparable phenomena.[2] This paralleling of ethics and aesthetics opens up a way of understanding how Cornford & Cross' artistry and their political agenda can be said to intermesh.

Wilde's argument will be looked at in greater detail later, but the paragraph above raises a more immediate problem. If the task is to look at the letter of the text it will also involve making assumptions about the work's boundaries; about what lies within rather than 'around' the works. As a self-managing and self-promoting team, Cornford & Cross generate a lot of writing. The texts that feature in this book have functioned variously as proposals, press releases and artists' statements. They have been subject to much revision and they represent a significant investment of the artists' time and attention. Are they part of the work?

Artists who write are not rare, but Cornford & Cross' writing activity as evidenced here is rather unusual — maybe more so than the artists themselves acknowledge. Using clear, direct language, the texts relate each project under examination to particular social and historical contexts and art-historical reference points. They frequently also detail the specific polemics that the artists understand each project to mobilise. Verbs such as 'refer', 'evoke', 'explore', 'engage' and 'relate' occur with some frequency. Each text involves a careful, systematic process of rationalisation, but also the kind of interpolation of potential associations and resonances that is more usually undertaken *post hoc*

by critics or art writers than by artists themselves when dealing with their own work.

Let's state here that these texts are not to be understood as tautologous, that is, as reiterations of the artworks' existing associative content. They are very much part of the work and therefore are legitimate objects for scrutiny under an aesthetic aspect. Here we should note that despite the continuing (twentieth and twenty-first century) erosion of certainties about the ontology of works of art, the idea that they are 'intransitive' — that is, that they give rise to meanings, ideas or effects that are quite specific to the work and cannot be exactly translated or reproduced in any other form — remains prevalent. If Cornford & Cross' texts are factored into the work, the idea that they constitute neutral, factual descriptions or representations must be dispensed with (irrespective of whether the objects and activities they describe were realised or remained at the level of propositions). Comprised in the category of intransitive artefacts, the texts themselves become available for a process of critical interpretation. Their omissions and inclusions, emphases, qualities of tone and other methods of address can be understood, in combination with the other components of the works, as manifesting Cornford & Cross' artistic style.

In the text describing *How Buildings Learn*, 2001–2004, Cornford & Cross offer a typically concise, reasonable-sounding description of activities which involved disrupting the flow of movement in the Chancery building housing the public archive of Pancevo, Serbia and Montenegro, disordering the archive, and getting the Chancery staff to collude in an act of — in the artists' own words — "controlled nihilism". The artists warmly acknowledge "the great generosity and public spirit" of the Chancery Director in letting them obstruct his organisation's normal working arrangements. One envisages a cast of characters — artists and hosts both — politely falling over themselves to facilitate the work's careful act of vandalism. Given that nihilism implies a disregard of all values, one would imagine it

excludes any considerations that might check its expression; the contradiction that Cornford & Cross have buried in the phrase "controlled nihilism" is, in fact, suggestive of the character of the project overall.

Cornford & Cross barricaded a double doorway using an assortment of ledgers, legal texts, financial documents, medical notes and Communist Party records from the town archive of Pancevo. Their text asserts that building the blockade involved 'intense labour' (a fact that might get overlooked, since the result is so neatly matter-of-fact; yet each chunk of the barricade must have weighed several kilos). It also emphasises that the archive contained no record whatsoever of Serbia and Montenegro's ethnic war, and it flags up a potential metaphorical reading: "*How Buildings Learn* could act as a sign... for the difficult, painful work yet to be done in relating history to memory." In fact, the 'physical block (or absence) equals mental block' metaphor seems the kind of meaning we would consciously decode from the work, more than feel; much more immediately affective is the idea of the artists' labour in itself, which hints at the old-school notion of the hard-won image and mobilises the assumption that something that has involved a big physical effort necessarily testifies to a sincerely held intention. The artists' text concludes by noting that the work's title references a book by Stewart Brand, advocating the development of building forms that can respond to the social needs of their users. However, the architectural modification made by Cornford & Cross hardly seems the kind of thing that Brand would have had in mind.

This work's earnestness and good organisation, its sensitivity to specific historical considerations, and its old-school aura of courtesy and hard work sit very strangely alongside its subtle facetiousness and its transgressive programme of physical obstruction and the suppression of information. This texture of contradictions colours or saturates the work's conscious content, producing a tension and instability that might be compared to the affect generated by musical counterpoint (an analogy that will be returned to later). This building-up of contradictory qualities is entirely characteristic of Cornford & Cross' style and, it is argued here, is central to what makes this an artwork.

II. Style and Character

Cornford & Cross have stated: "We maintain that as well as producing aesthetic experiences, a key function of contemporary art in an open society is to test concepts, assumptions and boundaries." This view of aesthetic experience – as a kind of surplus or separable component of the artwork's range of functions – seems different from the one that I advance here, so the task now is to defend that apparent difference of opinion, and to suggest how the production of aesthetic qualities through stylistic means both contains and conditions the function of testing concepts, assumptions and boundaries.

On the face of it, this seems to blissfully disregard two central tenets of twentieth century leftist aesthetics, which run as follows. One: to aestheticise the political is to translate it into some sort of transcendent domain where, neutralised, it becomes the object of pleasurable, disinterested contemplation. Two: to politicise the aesthetic is to instrumentalise it and cancel its critical distance from the ideologies of Western capitalism and the supposed free market. So, to propose to collapse an artwork's political content or project into its aesthetics seems to fall foul of both tenets and could be mistaken for a deeply reactionary move. However, there are various ways of construing the aesthetic that move beyond the notions of its necessarily serving as some kind of ideological disinfectant, neutralising agent or discrete realm of transcendent value. An account of the aesthetic that discovers a unity between ethical and aesthetic behaviour, for example, might offer a viable route around the polarity of autonomy and commitment that continues, in various forms, to stalemate contemporary criticism.

The statement "Ethics and Aesthetics are one and the same" appears in Wittgenstein's *Tractatus*, and in her essay "Ethics and Aesthetics are One", Carolyn Wilde sets out to see if the proposition makes sense in relation to Wittgenstein's later philosophy. Her investigation traces a complex chain of association between Wittgenstein's earlier and later views of ethics and aesthetics. To explain and defend the view that ethics and aesthetics are interrelated, it is necessary, briefly, to tease this out.

Drawing on the work of Cora Diamond, Wilde shows how, right from the start, Wittgenstein's philosophy dispenses with the idea of ethics as a set of abstract rules applied from some transcendent standpoint, after the event, to judge the consequences of subjects' actions. In Wittgenstein's view, ethics is not a discipline that bears on particular subject matter: "impartial judgement, the right or the good, happiness, the arbitration of interests, or whatever". Rather, ethics needs to be understood as "a condition of the world... [penetrating] all action by regulating what it makes sense to be or meaningfully do".[3]

However, this naturalistic idea of ethics as a kind of spirit or attitude that is immanent in human actions runs up against the logical argument in the *Tractatus*, that values — including ethical values — cannot be accounted for as worldly objects. To avoid ethics getting downgraded into some kind of psycho-biological mechanism, the *Tractatus* deals with the problem by asserting that ethical values may only be determined from a detached "point of view of eternity" — that is, from some disinterested metaphysical point of view outside of the world. This thesis ushers in a very problematic model of human subjectivity, splitting subjects between a world-bound, acting subjectivity on the one hand, and a metaphysical, contemplating consciousness — a consciousness possessing a kind of disinterested 'aerial view' of things — on the other.

If ethics and aesthetics are 'one and the same' and this concept is extended to encompass aesthetic evaluation,

more problems arise. A disinterested evaluation of an artwork, unanchored from personal or collective interests, memories, feelings or other sorts of human investment would be, if not absolutely impossible, then disengaged with much of what makes any work of art matter. However, Wilde maintains, an important insight is buried in Wittgenstein's idea of the "point of view of eternity": in some sense, aesthetic artefacts do invite both makers and viewers to take up a point of view that differs from everyday attitudes. The challenge is to resolve the split between the acting and contemplating subjectivities figured above.

Wittgenstein's later philosophy accomplishes this by reassembling ideas about intentionality. His later work overturns the idea that intentional processes such as 'willing', 'trying' or 'making an effort' can be thought of as the first part in a two-part procedure — as a separate 'mental event' preceding an action. They are part and parcel of the actions to which they pertain: "Willing, if it is not to be a sort of wishing, must be the action itself", wrote Wittgenstein.[4] When this proposition is related to the idea of ethics as "a condition of the sense of that which can be thought and done", it opens up a way of understanding ethics and ethical evaluation as permeating human behaviours and practices.[5] Agents' practices embody not just what actions they understand to be right or wrong, but their understanding of their circumstances overall, including the range of possibilities presented by those circumstances, and the interconnection of their ethical view with that of others. A subject's capacity for ethical reflexivity is therefore not to be found lurking in some private mental realm. It is intrinsic to and evidenced in a subject's actions — his or her choices and decisions, acceptances and refusals.

Wilde parallels this model of ethics with a similar model of aesthetic production and reception, embedded in practical procedures and social and historical specifics. The view of creativity that must be avoided is one that posits it as a

process of matching outcomes to preconceived 'mental objects'. She notes the idea (mobilised in many artists' accounts of the creative process) that a certain artistic logic or inevitability seems to drive the development of the work and suggests that, just as the sense of an individual's ethical character builds up through his or her actions, an artist's "method of attention as it is directed through the media of [... his or her] art" (including, presumably, an artist's sense of what is creatively possible, appropriate, and needed in the production of a given work) is manifested in the style of the artwork.[6] "Style in a work of art is [...] parallel to character in the formation of action", and it may feature in artworks both unselfconsciously and as a reflective, deliberate feature of the working process.[7] Relationships between individuals and culture are interdependent and interactive, Wilde concludes, and a key element of art's value lies in its capacity, through the aesthetic, to bring artists' particular imaginative constructions and perceptions into a public arena.

We might feel questions brewing around the modelling of both authorship and individual-cultural relations, as summarised above. First, doesn't this talk of style as parallelling ethical character usher in a host of unworkable humanist assumptions about the artwork as the trace or residue of the author's essential, founding subjectivity? The answer is 'no', because Wittgenstein's reconstruction of intentionality remodels the concept of self-expression. It does not consist of the imprinting of physical artefacts with pre-existent mental 'contents'; it is a process within a socially based language game. Second, if ethics is remodelled as permeating 'all action by regulating what it makes sense to be or meaningfully do', and aesthetics is identified with that model, doesn't this risk reducing not just artistic style but aesthetics *in toto* to something resembling the construct Nikos Hadjinicolaou (in his 1978 essay "Art History and Class Struggle") identified as "visual ideology" — re-conceiving aesthetics as a domain of intrinsically instrumental human thought and activity, in which subjects articulate and perpetuate their particular,

class-based, beliefs and interests?[8] Against this, it is nonsensical to condemn instrumentality *per se*. Instrumental thinking can be deployed against corrupt, unequal social realities, even if a base self-interest motivates the person deploying it. In addition, if ideologies are understood as generated in and through social practices and processes — as another kind of field in which differing models of truth may at least in principle be contested (even if, under capitalist hegemony, the ideological changes and modifications that receive legitimation are almost always tokenistic ones) — then the assertion that aesthetics and ideology share common ground starts to look less unpalatable.

Wilde's account is valuable in that, while maintaining a sense of the aesthetic as a distinct sphere of human activity, it firmly locates aesthetic values in actual, worldly practices and debates, and disrupts the idea that aesthetic judgement can have no intersection with political, moral or ethical judgements. "This conception of the aesthetic is not one in which art can be understood as existing in some autonomous realm of value. Neither can it call upon any simple notion of disinterest or unity. For it is this imposition of a false idea of unity and order on the representation of things that idealises and thus obliterates or sentimentalises social or psychological realities."[9]

III. Contradiction (with and without irony)

Cornford & Cross' style has been characterised earlier as expressing contradictory qualities side by side. Already we have evidence of their practice's resistance to simplistic reasoning and false resolutions. The works documented in this book also show Cornford & Cross making frequent, self-conscious use of motifs and devices derived from the Western landscape painting tradition and implicitly referencing the discourse of 'disinterested' aesthetics: the realm of art as the autonomous domain of the beautiful.

Coming up for Air, 2001, exists as a proposal to plant a concrete or steel chimney in a reservoir in Chasewater Country Park, Staffordshire. Cornford & Cross commissioned a marine artist to produce a watercolour visualising the (intermittently steam-belching) chimney *in situ*. It's a desolate prospect, showing a lowering sky and a line of electricity pylons stretching along the horizon; yet the artist's watercolour technique softens the impact and lends the image a surreptitious picturesqueness. In the booklet setting out the project, Cornford & Cross underline its sublime ancestry by including a reproduction of *Coalbrookdale by Night*, 1801, Phillip de Loutherbourg's infernal industrial landscape. During a residency at the London School of Economics and Political Science, Cornford & Cross evolved *The Lost Horizon*, 2003, a computer screensaver programme whose 'visionary' landscape image — a mountain spur rising from the sea (its implausible yet imposing form actually derived from London Stock Exchange data) — recalls *The Wreck of the Hope*, 1824, Caspar David Friedrich's paradigmatic sublime seascape.

For *Utopia*, 1999, the artists restored an ornamental pond in the grounds of Cadbury's sweet factory in Bournville, Birmingham, and installed a pair of fountains. Once the pond was repaired and refilled with water, the artists arranged for the water to be coloured with purple food dye. Photographic details of the water's surface show how the dye transformed the pond into a dark reflective mirror, a dramatic effect hinting at sublime visions of unfathomable depths or infinite space. (Matthew Cornford has described the moment the dye was added as "a moment of horror... the pond was really tranquil with butterflies and ducks, then this black oily substance began seeping into the water...".) The photographic record of the restored pond and garden shows grassy slopes, shady trees and a fountain (a purple fountain, admittedly, but a fountain nevertheless) at play against a deep blue summer sky. Contained within what, on close inspection, proves to be a rather neglected, unexceptional example of a modern-

era provincial civic garden, the artists discover the spectre of an elegant, patrician, neo-classical scene.

The success of Cornford & Cross' project *Childhood's End*, 2000, was more or less conditional on the presence of a clear summer sky, as its central device involved a fighter jet pilot skywriting the circled A of the Anarchy symbol in white smoke against the blue. However, the range of images that the artists have supplied to me over a period of years shows a notable expanse of similarly sunny, stereotypically photogenic fair-weather sky: in *New Holland*, 1997, *Jerusalem*, 1999, *The End of Art Theory*, 2001, and *Civilization and its Discontents*, 2004 version.

The wide-angle shots that Cornford & Cross often opt for could be explained away pragmatically as offering the best form of comprehensive visual documentation. But they arguably do more than that, because they capture large areas of sky, to the extent that it becomes a highly determining factor affecting the mood of the artists' photographs. *The Ambassadors*, 2001, proposed that, for the duration of the Liverpool Biennial, the three flagpoles on Liverpool's Cunard Building should be used to fly the flags of the nations with which Britain had no diplomatic relations at the time: Bhutan, Taiwan and Iraq. The proposal features a photograph of the Cunard Building dominated by a positively epic cloudscape. The building and its surroundings could hardly be pictured more augustly. And in *Cosmopolitan*, 1998 version, a steel shipping container is set against a striking pink-tinged sunset sky. Given that the container served to screen a videotape of Russian women who are effectively mail-order brides, the sunset sky forms a subtly equivocal backdrop. It might be read as a straightforward invocation of the romance of urban twilight, or as melancholic hokey: a dream of 'going west' in the direction of cliché and anomic commercialised culture, the end rather than the beginning of hope.

Cornford & Cross' mobilisation of the art-historical traditions and visual protocols of urban and rural landscape is

intrinsic to their exploration of contradictions between the ideological myths and political realities of the organisation of space. Via these artistic tropes they raise questions about citizenship, class, economic power and the ownership and control of land. *Coming up for Air*, 2001, associates sublime imagery with the enlightenment/modern project of dominating nature. Both *Jerusalem*, 1999, and *Utopia*, 1999, suggest how the costuming of English landscape in stereotypical Classical and Romantic attire helps to mask questions of ownership and access. However, we could derive such polemics – "problematising the notion of a disinterested aesthetics" or "questioning canonical notions of beautiful landscape" for instance – from a variety of other critical and historical sources. Fundamentally, Cornford & Cross' work is compelling because its style represents their imaginative construction of these artistic problems as complex and equivocal, not univocal and dogmatic. The artists' own stylistic idealisations invest in the affective power of a number of traditional aesthetic tropes, even as they question their applications. In *Utopia*, for example, the artists' photographic idealisation of Bournville Women's Recreation Ground parallels their effortful restoration of the pond in actuality, reconstructing a benign-paternalist 'Utopian' scene that is also a Utopian image. Before the artists went to work, the pond had been filled with building waste and had to be completely cleared out, so here, as in *How Buildings Learn*, the artists juxtapose the sincerity implied by hard physical work with a disruptive, (partly) cynical gesture: in this case, dyeing the pond Cadbury-chocolate-wrapper purple. Cornford & Cross' blue skies reference a repertoire of landscape imagery largely co-opted by conservative values and placed in the service of a contemptible, false idealism. See the photograph of *Jerusalem*, for example: "Here is the sunlit, daisy-strewn greensward, here the magnificent trees and the cricketers at play, here the lofty cathedral spire – and here's the plucky boy soldier, ready to give his all to protect this idyll." Despite this, the *Jerusalem* photograph is not a univocal parody of a 'beautiful' image; it is formally and associatively a beautiful image.

In *Childhood's End,* 2000, the artists' text acknowledges the optimistic affect of the blue sky against which the work was (literally) inscribed. The correlation of clear skies and flight with a sensuous apperception of freedom and optimism is central to this work's building of contradictory feelings – hope and anxiety – around the idea of transgression. And in *A Month in the Country*, 2004, the artists' text features an omission so striking it demands to be registered as a strategic aesthetic decision. The project involved hiring and displaying four photos, classed as "East Anglia landscapes", sourced from the 70 million images held by the Bill Gates-owned stock photography company Corbis. Once the artists' month-long licence with Corbis had expired, they obscured the images with whitewash, but left them (at least technically) on display. The work's text sketches the content of the novel by JL Carr from which it takes its title, but omits a central fact: that in essence it is a desperately poignant love story. The affective charge of the novel's emotional themes – the tragedy of the First World War, the failure to grasp happiness when it is in reach, and the loss of youth – is built up through and around the love story. Cornford & Cross' decision to suppress this crucial detail infuses their work's calculated polemic (about the commercial control and withholding of information) with a quality of concealed emotion. It produces another deep contradiction, setting a calculating, goading, catch-us-if-you-can attitude of legalistic provocation against a half-buried, but nevertheless very exposing, declaration of Romanticism regarding the role of emotion in art.

Does this project of expressing incompatible qualities exemplify postmodern irony? Cornford & Cross' work is certainly postmodern, if we understand the postmodern to signify a condition in which the problems of capitalist modernity and globalisation are not superseded but intensified, and irony certainly features as part of its range of expressive registers. However, the problem with 'irony' as an overall descriptor is that in the context of postmodern aesthetics it usually implies a self-undermining mode of

address that holds out significations with one hand but snatches them back with the other — a conservative tactic of disavowal that refuses to take responsibility for its utterances. Earlier, Cornford & Cross' generation of contradictory affect was compared to musical counterpoint, and this needs clarification. Musical counterpoint doesn't always produce a sense of contradictory qualities. When it does, however (juxtaposing themes suggesting longing and resignation, say, or elation and anxiety), the effect is hardly ever ironic; the impact of the music hinges on the incompatible qualities remaining preserved in themselves without one undercutting or disallowing the other. In a similar way, Cornford & Cross' aesthetic style self-consciously owns the contradictions it generates, positing unreconciled positions that express contending convictions, not a hollow scepticism in which oppositions cancel each other out.

Needless to say, this essay is not advancing the view that art should help reconcile audiences to the political tensions or contradictions it articulates. Rather, it suggests that prompting people to focus more clearly on their situation without oversimplifications or evasions is, in most situations, a valuable activity. David Cross articulates this attitude: "I channel my own discontent into expressing more or less incompatible opinions, which draws me into debate, and obliges me to order my thoughts and make choices based on explicit values."

In conclusion, we might note the currency of the idea that embracing uncertainty about the way forward in itself constitutes a vital part of the present-day project for radical politics. This essay argues that Cornford & Cross' art practice does not represent a vacillation between a progressive cultural politics and a *retardataire* investment in obsolete cultural forms, but embodies an acute sense of resistance to the "imposition of a false idea of unity and order on the representation of things". This resistance finds its core expression in the aesthetic contradictions the work self-consciously generates and shares with its audiences. Cornford & Cross' aesthetic style is evidently

not equivalent to 'the work', but it is at the heart of the work; rejecting both anti-aesthetic negation and hollow postmodern irony, it challenges viewers to review and clarify their own aesthetic and political values by presenting powerful antitheses in good faith.

Rachel Withers is an art critic and writer. She teaches at Wimbledon College of Art, and is a frequent contributor to *Artforum International*.

1. Terry Eagleton, *The Ideology of the Aesthetic*,
Oxford: Blackwell, 1990, p. 3.

2. Ludwig Wittgenstein, quoted in Carolyn Wilde, "Ethics and Aesthetics
are One", in Peter Lewis, ed., *Wittgenstein, Aesthetics and Philosophy*,
Aldershot: Ashgate, 2004, p. 165.

3. Wilde, p. 166.

4. Ludwig Wittgenstein, *Philosophical Investigations*,
Oxford: Blackwell, 1953, p. 160.

5. Ludwig Wittgenstein, quoted in Carolyn Wilde, p. 182.

6. Wilde, p. 183.

7. Wilde, p. 183.

8. Nikos Hadjinicolaou, *Art History and Class Struggle*,
London: Pluto Press, 1979.

9. Wilde, p. 184.

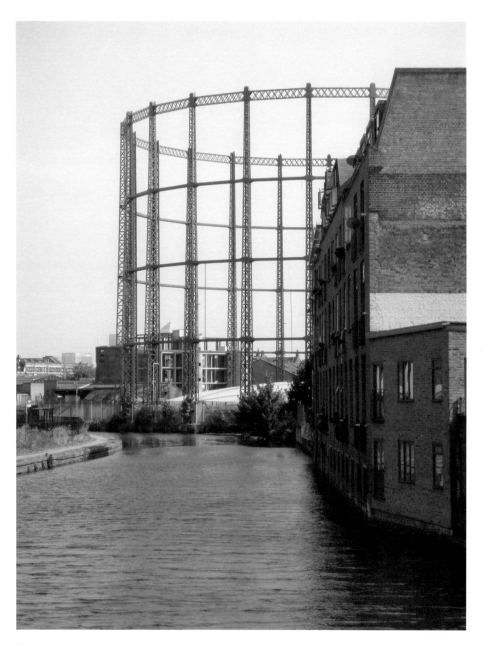

Empty gas tower
Hackney, London, 2008

Works

Cornford & Cross

Operation Margarine, 1995
Camelot, 1996
Golden Triangle, 1997
Power to the People, 1997
Get Carter, 1997
Avant-Garde, 1997
New Holland, 1997
Cosmopolitan, 1997
10, 1998
This England, 1998
The Return of the Real, 1998
Problems Solved, 1999
Jerusalem, 1999
Utopia, 1999
Art School, 1999
Childhood's End, 2000
The End of Art Theory, 2001
The Ambassadors, 2001
Coming up for Air, 2001
How Buildings Learn, 2001
Painting as a Pastime, 2001
The Treason of Images, 2001
Civilization and its Discontents, 2001
The Lost Horizon, 2003
A Month in the Country, 2003
The End of History, 2004
She, 2004
Where is the Work?, 2004
Why Read the Classics?, 2005
Fire Down Below, 2007
Words are not Enough, 2007
Trance Nation, 2007
The Abolition of Work, 2007

Operation Margarine 1995

Operation Margarine was made in response to an invitation from the artist and curator David Blamey, who asked a number of artists to make a work that combined a book of their choice with "something else".

As students at St Martins we had enjoyed *Mythologies*, the 1957 book by Roland Barthes, who brought wit and economy to critical engagement with the everyday. An English paperback edition features on its cover *Just What is it that Makes Today's Homes So Different, So Appealing?*, 1956, the seminal collage by the artist Richard Hamilton, based on a design by John McHale, for the exhibition This is Tomorrow at the Whitechapel Gallery, London. Hamilton was to develop a longstanding interest in the German industrial design company Braun, and he later produced several works based on the publicity material for a Braun toaster.

Dropping the paperback book into the electric toaster almost concealed the Pop Art collage, associating the techniques of censorship with advertising, and identifying a totalitarian impulse within consumerism.

Operation Margarine is the title of Barthes' essay which identifies and confronts a tactic common to advertising and propaganda: focusing attention on the most questionable aspect of a product or system as a way to manufacture consent for it.

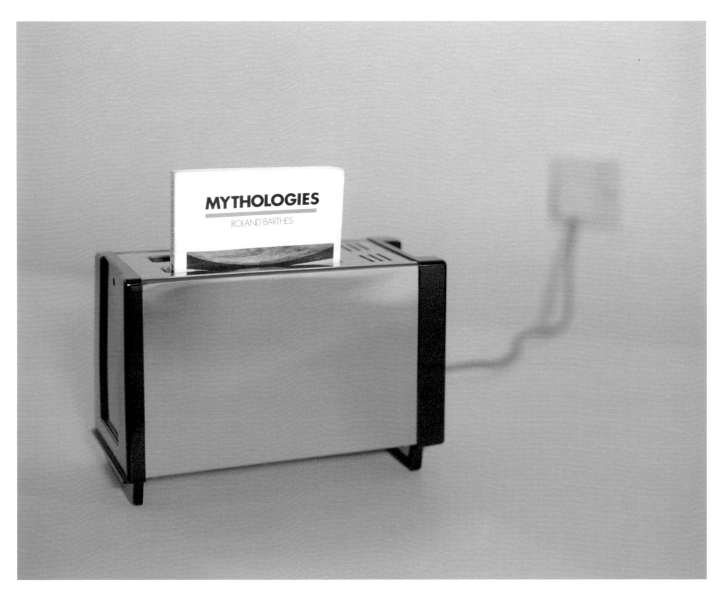

Operation Margarine, 1995
Paperback book in electric toaster
Collection of Daniel Brooke

Camelot 1996

For a group exhibition in Stoke-on-Trent titled City Limits, we chose to invite reflection and debate on the physical and social boundaries that often determine the patterns of city life – in this case by denying people access to some small, neglected fragments of public urban land.

Although the site we chose marks the entrance to Hanley town centre, it was defined only by three irregularly shaped patches of grass, flanked with sloping brickwork and cut off by traffic on either side. Rather than using a public art commission to superficially enhance the site, we decided to make an intervention that would engage with the very conception of 'Public'.

By reinforcing the boundaries of these grass verges with an excessive display of authority in the form of steel security fencing we allowed the public to see but not to walk on the grass, raising the status of the land through its enclosure. In the context of the contemporary debate around security and access within town centres, Camelot explored the political notion of the "Tragedy of the Commons" in which resources not under private ownership fall into neglect.

The project title, Camelot, refers to the phenomenally successful United Kingdom National Lottery, an institution on which many artistic and cultural projects were becoming increasingly dependent for money. The Lottery organisers' choice of the name "Camelot" evokes a mythical 'golden age' of English history, when the court of King Arthur established fair play in a feudal society through the code of chivalry. Perhaps the old idea that only the accident of birth separates the prince from the pauper underlies today's popular interest in the journey from rags to riches through the luck of the draw.

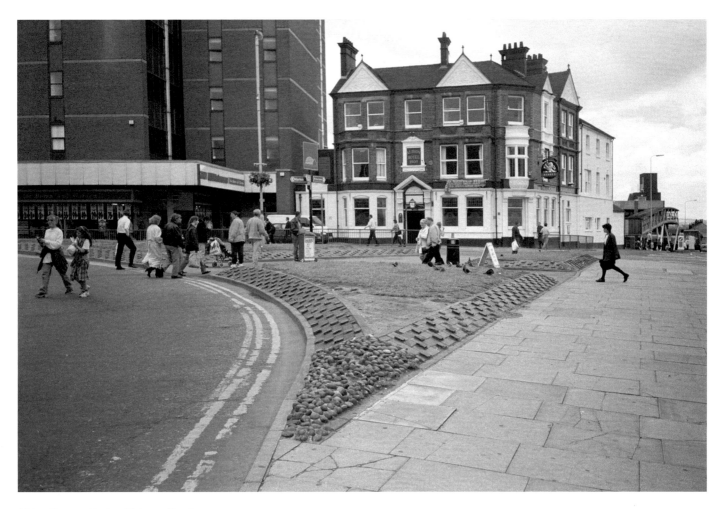

Albion Square, Hanley, Stoke-on-Trent,
England, 1996

Left:
Damaged ground flanked by 'anti-pedestrian'
brickwork
Albion Square, Hanley, Stoke-on-Trent,
England, 1996

Centre:
Stacked fencing materials on site
(note the absence of pedestrian crossing)

Below:
Camelot during construction

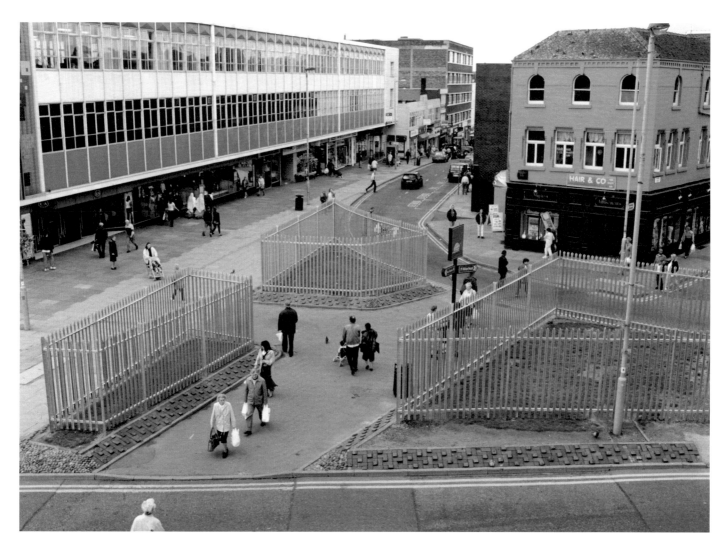

Camelot, 1996
Public space enclosed by security fencing
View from local Tax Office
Photograph courtesy of *The Sentinel* newspaper
Stoke-on-Trent, England

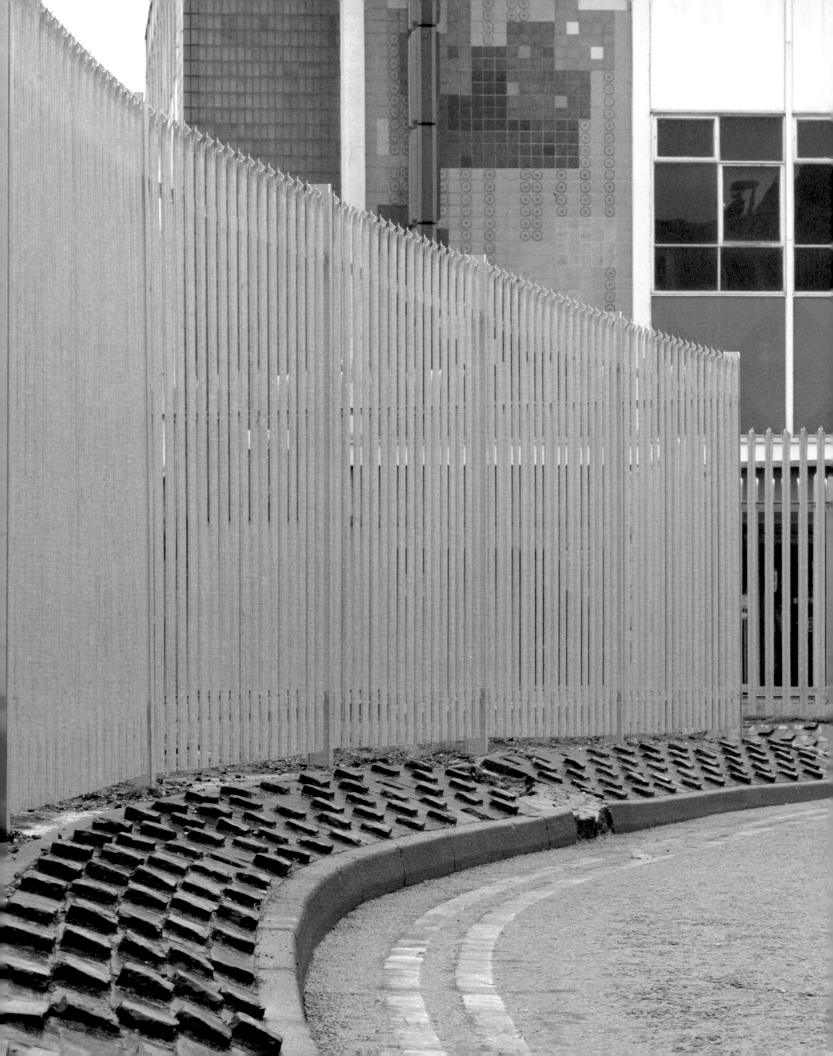

Camelot, 1996
Public space enclosed by security fencing
Albion Square, Hanley, Stoke-on-Trent, England

Golden Triangle 1997

We were invited to take part in Backpacker, a group exhibition in Chiang Mai City, Thailand. We accepted the invitation, but chose not to go. Instead, we made a work that could be installed on our behalf, by fellow artists David Blamey and Roman Vasseur.

We sent out three similar but different radios, with instructions for them to be installed for the duration of the exhibition on a table in the lounge bar of an international hotel. We specified that the radios should be positioned to make an equilateral triangle, with each one facing inwards. And for one hour every day at 12 noon Greenwich Mean Time (7pm local time), each radio was turned on and tuned in at the same moderate volume to a different station: the BBC World Service, Radio Chiang Mai and Smooth 105FM.

"The Golden Triangle" is the name given to an area of northern Thailand, eastern Burma and western Laos historically notorious for its opium production.

Golden Triangle, 1997
Chiang Mai City, Thailand
Photograph by David Blamey and Roman Vasseur

Power to the People 1997

We held a one-day record fair within the exhibition space of the Bluecoat Gallery, Liverpool. To attract different audiences, the fair was promoted on posters locally and advertised in both specialist music magazines and the art press. This live art event set out to undermine the distinction between high and low cultural forms, and the spaces that house them. Some people came to the fair to buy records; others came to the gallery to see art. Both groups participated in a happening.

A record fair in a gallery became an occasion for celebration and critique, not just of music, but of late-twentieth-century attitudes towards heritage and what is to be done with it. Consumer culture has an increasingly complex relationship with retrospection, conservation and nostalgia. Such a preoccupation suggests at the same time an awareness of the achievements of the past and also a failure to invest (both imaginatively and financially) in the future.

Record-collecting, in particular, is full of such paradoxes. To reconnect with lost moments of youthful freedom, collectors seek out pristine copies of ephemeral cultural objects, and then order and categorise them. The alchemical process of time has made precious that which was generally regarded as being of little artistic value. Just listen to dealers and collectors rhapsodising on the idiosyncrasies of sleeve design, special pressing or label colour, and you are in on a discussion about the history of postwar art and design. The fervour and expertise of 'vinyl junkies' is as strong and committed as that of the gallery-goer, curator or critic. The difference is one of category and perhaps class.

Power to the People, 1971, is the title of the counterculture pop anthem by John Lennon Plastic Ono Band.

With thanks to John Beck for his contribution to this text.

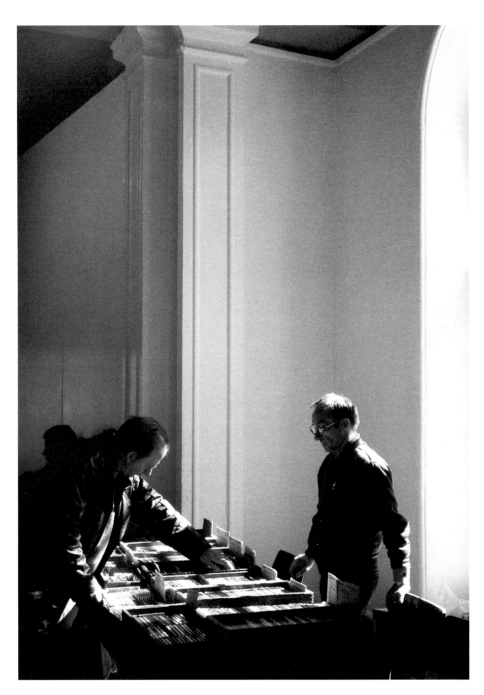

Power to the People, 1997
Bluecoat Gallery, Liverpool, England

Get Carter 1997

We proposed to install a fully operational prison door into the entrance of the Laing Art Gallery in Newcastle upon Tyne, England. All other doors and windows into the gallery space were to be closed and sealed.

The prison door was to be controlled by a private security guard, instructed to allow only one person in at a time. Entering the enclosed space would have constituted an act of voluntary submission, as the guard would have locked the door for an undisclosed period. While inside, the viewing subject would have become an object of enquiry to the gallery-going public.

Ascetics enter confinement to attain a higher state of consciousness, while prisoners of conscience do so as an act of defiance. In our proposed installation, the experience of quiet contemplation within the 'white cube' of a contemporary art gallery would have been mixed with the anxiety and frustration of solitary confinement in a prison cell.

In a society's manufacture of consent and control of dissent, a spectrum of approaches and institutions might be identified, ranging from those based on co-option through cultural consumption, to those based on coercion through law enforcement. Our proposed installation aimed to connect the two.

Get Carter, 1971, is the title of a film directed by Mike Hodges, starring the actor Michael Caine as a London gangster who travels to Newcastle to avenge his brother's killing.

Page from product catalogue
Courtesy of Cell Security Ltd,
Bolton, England, 2008

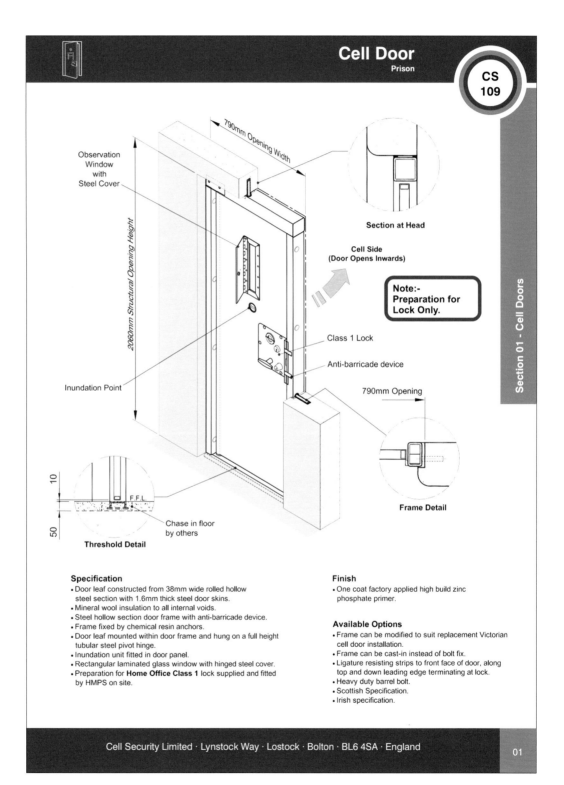

Cell Door
Prison

CS 109

790mm Opening Width

Observation Window with Steel Cover

2060mm Structural Opening Height

Section at Head

Cell Side (Door Opens Inwards)

Note:-
Preparation for Lock Only.

Class 1 Lock

Anti-barricade device

Inundation Point

790mm Opening

Frame Detail

F.F.L.

10

50

Chase in floor by others

Threshold Detail

Specification
- Door leaf constructed from 38mm wide rolled hollow steel section with 1.6mm thick steel door skins.
- Mineral wool insulation to all internal voids.
- Steel hollow section door frame with anti-barricade device.
- Frame fixed by chemical resin anchors.
- Door leaf mounted within door frame and hung on a full height tubular steel pivot hinge.
- Inundation unit fitted in door panel.
- Rectangular laminated glass window with hinged steel cover.
- Preparation for **Home Office Class 1** lock supplied and fitted by HMPS on site.

Finish
- One coat factory applied high build zinc phosphate primer.

Available Options
- Frame can be modified to suit replacement Victorian cell door installation.
- Frame can be cast-in instead of bolt fix.
- Ligature resisting strips to front face of door, along top and down leading edge terminating at lock.
- Heavy duty barrel bolt.
- Scottish Specification.
- Irish specification.

Cell Security Limited · Lynstock Way · Lostock · Bolton · BL6 4SA · England

01

Avant-Garde 1997

Our proposal for the 'Brighton Seafront Public Art Commission' took as a starting point the representation, myth and collective memory of Brighton, England, as a Bank Holiday destination for displays of public disorder by rival gangs of 'Mods' and 'Rockers'.

We proposed to make a billboard-sized enlargement of a news photograph of Brighton's first May Day 'riots' in 1964. This would have been installed on the Aquarium Terrace, the scene of the actual riots.

Brighton Seafront is connected to the history of military conflict along the coastline and beaches of southern England. The 1960s generation of British youth was the first not to undergo National Service after the Second World War, while also benefiting from the economic prosperity of the postwar period. The Mods' and Rockers' rebellious behaviour and conspicuous consumption carried enough symbolic effect for them to be initially represented and dealt with as a significant threat to the established order.

Decades of cultural reference and quotation are now interposed between the present and that original time. By re-presenting this iconic photograph, *Avant-Garde* would have interrogated the use of photography to structure imaginative access to the past.

Avant-Garde considered how male violence becomes variously suppressed by the State, presented as spectacle in popular culture, or valorised and incorporated into official history. Yet the photograph tells little of the complexities of class and gender in an important, albeit hedonistic, struggle against the restrictions of society. As an official commission which aestheticised youthful rebellion, this project would have been an example of recuperation, the process by which the social order is maintained.

The expression 'avant-garde' derives from a French military term, which was later used in revolutionary politics. Under modernism it became a term of critical approval for experimental arts. As the term became widely used to describe anything fashionable or novel, it finally reached exhaustion and fell out of contemporary use.

Proposed location for *Avant-Garde*
Aquarium Terrace, Brighton, England, 1997

Overleaf:
May Day 'riot'
Aquarium Terrace, Brighton, England, 1964
Courtesy of Brighton Local Studies Library

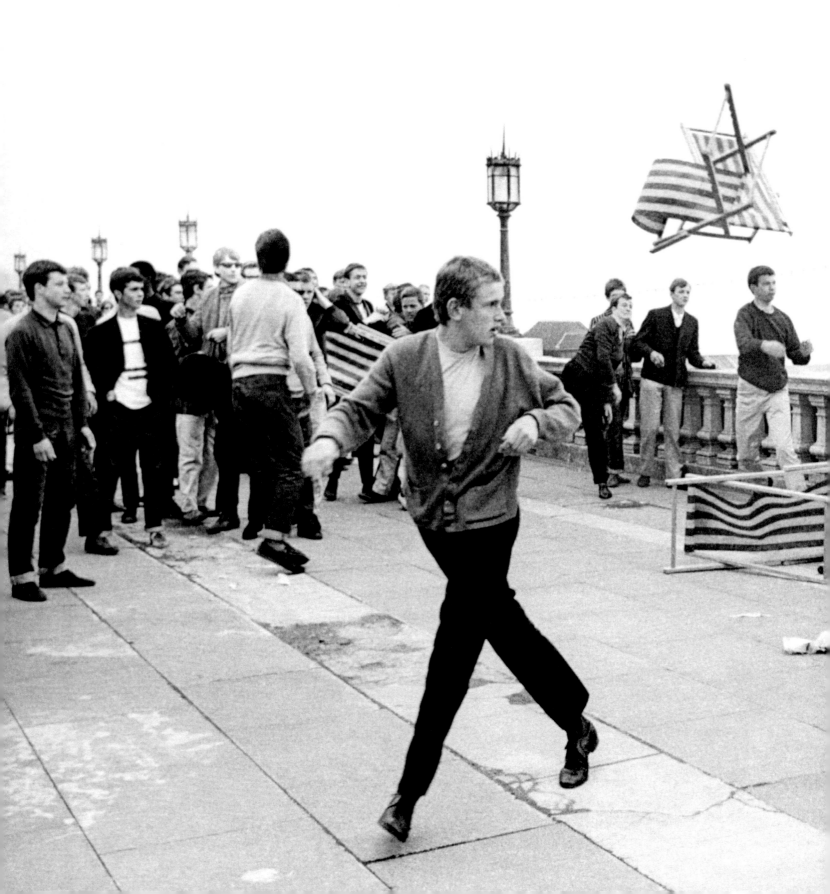

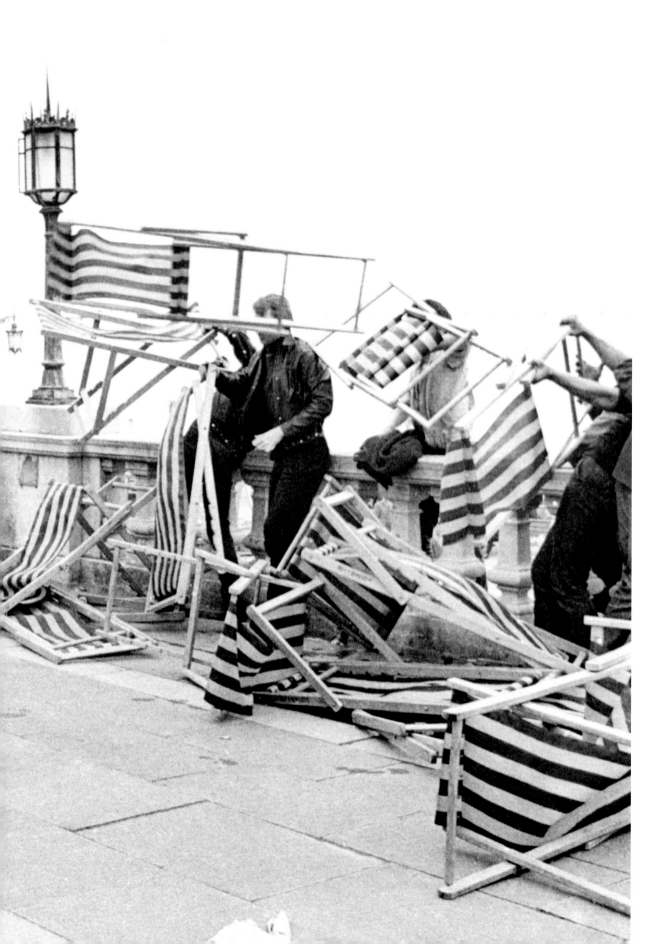

New Holland 1997

New Holland considered the relationships between architecture, economic activity and cultural responses to the English landscape. The installation consisted of a steel structure, based on an industrial agricultural building, and positioned near a Henry Moore sculpture outside Norman Foster's celebrated Sainsbury Centre for Visual Arts. In size and proportion, our structure referred to a 'Bernard Matthews' turkey breeder unit, though it had neither doors nor windows. Loud House and Garage music from CD compilations blasted out from the darkness inside.

New Holland exploited tensions between the English Romantic representations of landscape exemplified by Moore's sculpture, the space age 'functionalism' of Foster's architecture, and the realities of modern agriculture in Norfolk's intensive turkey farms. The structure was entirely appropriate yet uncomfortably out of place in its physical setting and institutional context. We positioned the work to question the Sainsbury Centre, yet the piece was not created in terms of a simple opposition: instead, *New Holland* occupied a space of controlled rebellion.

Spatially, the piece divided and linked the Sainsbury Centre and the 'reclining figure' sculpture nearby. Foster's building, which proposes a technocratic patriarchy, and Moore's vision of nature as 'Mother' signify two sides of modernist ideology in relation to the environment. Architecturally, the barn's standardised components and system-built construction methods related to the functionalist rhetoric of the Sainsbury Centre. We visited a Bernard Matthews turkey farm, and connected it with Foster's references to aviation in the Sainsbury Centre, since the barns are built directly on the old runways of a former US air base.

Visitors approaching the Sainsbury Centre were confronted with a bland but imposing structure clad in polyester-coated pressed steel (as preferred by planning committees). *New Holland* referred primarily to a modern-day farm building, but would be equally acceptable in a retail park or industrial estate. However, in the beautiful grounds of the University of East Anglia it could be seen as the 'country cousin' at a garden party, or yet another infill development in an unspoilt rural idyll.

The House and Garage music played on the notions of rebellion in the piece, with the mechanistic succession of repetitive beats evoking the urban invasion of the countryside for illegal raves, a form of youthful dissent that was steadily becoming absorbed into the blind hedonism of mainstream consumer culture.

Birkin Haward OBE FRIBA
The Sainsbury Centre
Architecture Design, vol. 49, no. 2, 1979

Left:
"More and more, day and night, the air of our quiet countryside is filled with the drone of aeroplanes — our aeroplanes — as they take part in our mounting air offensive against the Axis powers. Here Stirling bombers near the coast cast their menacing shadows before them."
Caption on reverse of photograph
Courtesy of the Imperial War Museum, London

Below:
New Holland combine harvester
East Anglia, England, 1997

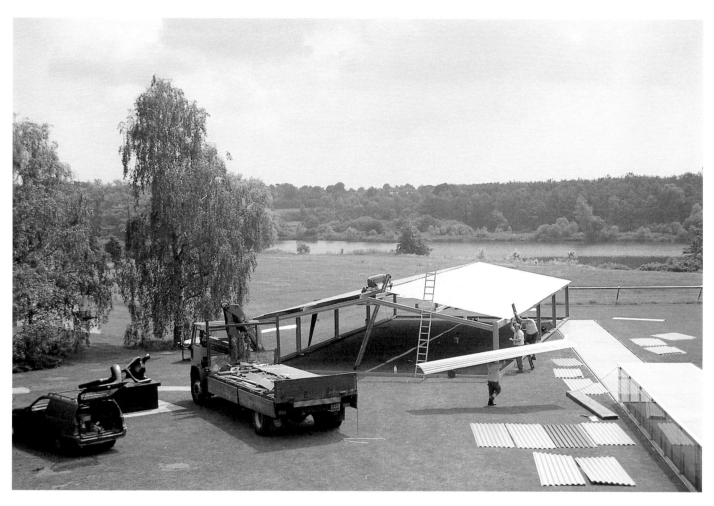

New Holland under construction
Sainsbury Centre for Visual Arts,
University of East Anglia,
Norwich, England, 1997

New Holland, 1997
Steel construction and sound system
Sainsbury Centre for Visual Arts,
University of East Anglia, Norwich, England

Cosmopolitan 1997

Cosmopolitan used videotapes bought from marriage agencies which presented interviews with women from the former Soviet Union seeking potential husbands in the West.

The outdoor installation of *Cosmopolitan* consisted of a video screen, projector and sound system fitted in a steel shipping container on its trailer. The trailer and container are interchangeable components of the globalised transport system — here, the trailer became a plinth for the shipping container, which framed the video screen. In this way, *Cosmopolitan* combined image and commodity, while evoking an American drive-in movie and a Russian Constructivist mobile cinema.

At dusk, the container doors were opened to reveal the screening of interviews with hundreds of Russian women. One after another, the women presented themselves to the camera with gestures, clothing and hairstyles which signified 'femininity' in the codes of Western visual culture of the recent past. Off screen, a North American male questioned each woman with a degree of repetition and at a pace which by turns suggested interview, audition and interrogation. The videos were sold with lists detailing each woman's name, age, height, weight, marital status, occupation, and a summary of her personal aspirations.

However, many of the women's responses suggest that they were not simply being exploited as commodities, but were choosing to enter a more complex transaction driven by economics, framed by socio-political change and facilitated by technology. If video contributed to the erosion of communism by spreading Western images of property and consumption, then perhaps marriage agencies trade on the resulting desire to live out fantasies of globalised media imagery. *Cosmopolitan* highlighted the bonds between individual freedom and particular social, economic and political conditions, to unsettle the adage that 'the personal is political'.

Whatever opportunities awaited these women, they were taken at a cost of leaving friends, family and home, to begin new lives with almost total strangers. The exodus of so many healthy, intelligent and skilled women of child-bearing age may have indicated a widespread disaffection with their prospects in the former Soviet Union. Yet if this threatened "a crisis of Russian masculinity", it could equally be argued that the marriage agency process was symptomatic of dysfunction among men in the West. Despite its allusions to material and emotional fulfilment, *Cosmopolitan* delivered only emptiness, masked by a vision of desire.

View from a worker's apartment
Moscow, 1998

INTERVIEWEE: My name is Sversa –.

INTERVIEWER: *Hi Sversa. What is your age?*

I am 28 years old.

And Sversa, what is your profession?

For the time being, I study at Tver Medical Academy. I am in my sixth year.

And... after you graduate, what will you do?

I'll be a women's doctor.

I see, and this is specifically to do with...?

Yes – with delivering babies.

Wow, how exciting. Great. And was that your sister that was just here before you?

Yes, she was my sister.

How's your relationship with your sister?

We have really good relations.

Ever any problems?

No.

Good. Do you guys ever... uh, double date – go out with two guys as a group?

Yes, there was once.

How did it go?

Great. Perfect!

Really? Uh... what about your interest in the opposite sex. What kind of a special man are you looking for?

Kind and intelligent, I think these are the main qualities.

Have you ever been married?

Yes, I was married.

Do you have children?

No.

And about American men – do you know anything about American men?

I think men are men everywhere. I think just... just we have the same men as you have.

How are you and your sister different in your approach to finding a man?

I think she's more romantic because of the difference in age. She is younger – that's why she visits discos all the time.

I see. And you are 'out' on the disco scene! Uh, well... you both have... actually, the whole family seems to have beautiful genes. So, I am glad that you're going to deliver more babies into the world and hope you'll make the city a more beautiful place. Thank you for coming in today.

INTERVIEWEE: My name is Maria –.

INTERVIEWER: *Hi Maria. How old are you?*

I am 18 years old.

Is it possible that you'll be 19 soon?

I'll be 19 in October – it's possible!

Are you a student right now at Tver University?

Yes, I'm a student.

OK, and what would you like to become in your future profession?

For the time being I study at the Law Faculty according to my profession.

Like a paralegal, or like a lawyer?

Like a lawyer.

Really. Is this a good country to practise law in?

[long pause] It depends upon where I work.

America has about 100,000 lawyers — it's the profession of America. So, it's a good place for you.

A legal country.

What about for fun — what do you do in your spare time?

I enjoy cooking and I enjoy working in my garden. I also work to take care of my brother, though he's not my immediate brother.

I see. Good, good. Now, do you want to settle down and have a family some time soon?

Yes.

Describe the man of your dreams.

I like strong, independent men. I enjoy a man that like families and like children. I want him to be a very good protector for myself.

If you meet the right man are you ready now to go to America, start a new life?

If I like him very much I will.

Will you meet men who are 30 or over?

If I will like him very very much.

Great. Thank you for coming in today. I'm sure you'll get many letters.

INTERVIEWEE: My name is Arlova —.

INTERVIEWER: *Hello Arlova. How are you today?*

Like every day — not bad.

OK. Tell us how old you are.

37 years old.

Are you happy about that?

No, I'm a little bit sad.

Why?

I think a little bit too much.

Don't think — just answer these questions. Have you been married before — do you have children?

I was married and I have a very nice son. My son is 14.

Is your son friends with our previous lady's friend's son? Are they better friends than you two?

They are the same. But we have women's friendship and we have men's friendship.

Yes, it's entirely different. Tell us about your career — are you working right now?

Yes, I am working. I have graduated from the Tver University Economical Faculty, and now I prepare to go into my profession as an economist. The career and my work wasn't the purpose of my life. I think family and home is more important for a woman.

What's important in a man?

Reliable, intelligent and decent. With a sense of humour, of course.

That's all you need?

Yes.

Wow! Open the floodgates! Get ready for some letters.

Thank you.

OK. And, are you serious about coming to America and starting a new life?

[pause] I can't say exactly, but I would like to.

OK. Is age important to you in a spouse?

The age of a man? No, it doesn't matter — just I wish he would be the only person.

OK. Thank you for coming in today.

INTERVIEWER: *Good Afternoon, Svetlana. How old are you?*

INTERVIEWEE: I am 19 years old.

And are you a student right now?

No. I have graduated from the Tver College this year, and my future profession will be an accountant, auditor.

And are you working right now?

No, not yet.

OK. And what are your plans for the future – are you looking to get married soon?

I think yes.

OK. Why did you decide that you didn't want to go to the University?

No, soon I have examinations. I have to take exams to enter the University.

OK. Now, what do you do in your spare time now that you have a lot of time?

I enjoy reading very much. I do a lot of sports. I enjoy going to the theatre.

OK. What about... social life? Are you, uh, dating anyone right now?

Not now.

OK. You're looking for a partner for life?

Mm-hm.

Describe the ideal man.

I would like to see a man that is respectable, intelligent and reliable. I want him to love me, to respect me and take care of our children... and to take care of our family.

Well then, you sound pretty serious about your future. OK. Now will you date a man if they are a little older, maybe in their early 30s?

If I like the person, why not?

How did you find out about our programme?

My friend told me.

Have you always been so soft spoken?

Practically, yes.

Good. Now – do you know anything about our country, America?

Yes, I was in America once.

How did you come – with family, or...?

I lived with an American family in Montana State.

What was the name of the city?

Wolf Point.

Wolf Point, Montana! And what do you remember about America?

I also visited some different cities while staying there and we visited some American schools.

That's good. You're one of the few girls that I have ever met in Tver that has been in America. Do you know anything about California, or just Montana?

No.

If you had your choice, would you rather marry a man from Montana?

It depends upon the person, how I like him.

Great! Well, I'm sure you'll get a lot of letters. And we hope that you're successful and have a good life in America.

Cosmopolitan, 1997
Video still from USA marriage agency
interviews with Russian women

Cosmopolitan, 1998 version
Video projection of USA marriage agency
interviews with Russian women, shipping
container, private security guard and dog
Pierhead, Liverpool, England
Photograph by David Pearson

10 consisted of a beauty contest judged by facial recognition software. In this contest, all personal traits that may be socially acquired were excluded; entrants were judged only on their facial beauty. The judging process was presented as free from human error and bias: entrants' faces were photographed under controlled conditions, then analysed using police and security facial recognition software. The computer compared contestants' faces to an 'ideal' of symmetry and proportion and then selected the winners from its own numerical ranking of the scores. We gave away our artists' fee of £3,000 to the winners.

In a spirit of fairness and equality of opportunity, the contest was open to everyone over the age of 16 who lived, worked or studied in the Derby 'City Challenge' area. Entry was free, and expenditure on clothes, make-up or portrait photographs gave entrants no advantage. *10* linked the Montage Gallery with people in the City Challenge area through their active participation in the project and subsequent debate, rather than through a social documentary survey.

This project took place in the context of a re-emergence of 'Social Darwinism', which asserts that genetic heredity plays a greater role than social factors in the individual's success or failure, and proposes that survival of the fittest is the inevitable response.

The Human Genome Project has transformed our understanding of biology, while promising new products and services including the isolation of specific genes for criminality, sexuality, health and beauty. *10* aimed to provoke public debate around this systematic codification of social selection and rejection, and to encourage people to question their own judgement of physical appearance in relation to issues of equality and elitism, social mobility and entrapment.

Study for *10*

Based on research by MR Cunningham

Journal of Personality and Social Psychology,

vol. 50, no. 5, 1986, pp. 928–929

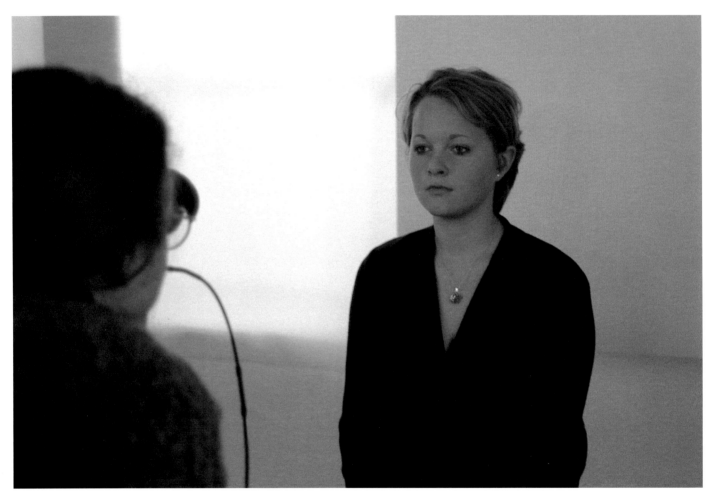

Above:
Beauty contestant Emma Simpson being
photographed at the Montage Gallery, Derby,
England, 1998

Opposite:
35mm photographic contact sheet of beauty
contestants' faces

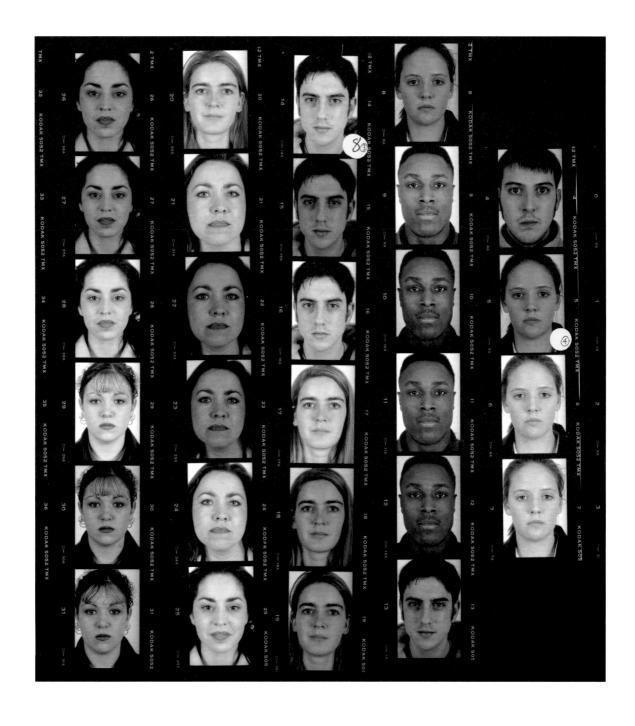

65

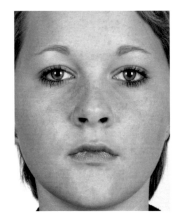

10. *Simpson, Emma, £75.26*

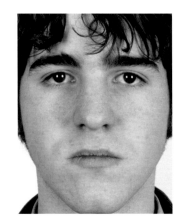

9. *Finiw, Zenon, £80.44*

8. *Brookes, Naomi, £103.88*

7. *Clements, Stephanie, £142.53*

6. *Heitman, Katie, £162.29*

5. *Joyce, Tara, £202.18*

4. *Ramsdale, Tracy, £349.20*

3. *Goldsworthy, James, £447.52*

2. *De Ville, Timothy, £600.15*

1. *Rigby, Rachel, £836.55*

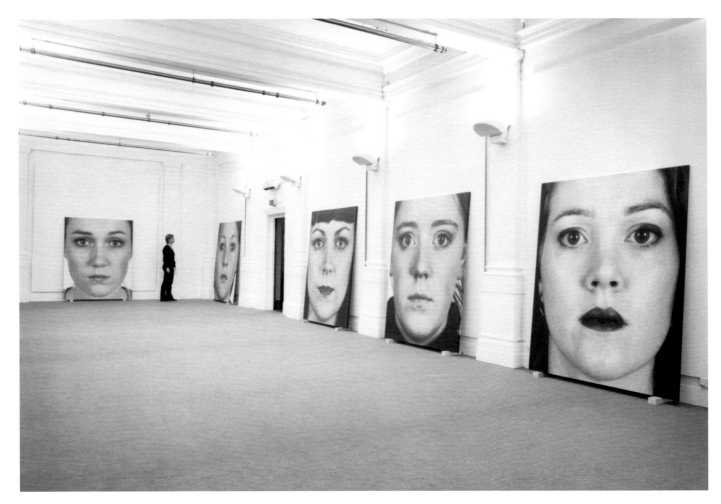

Above:
10, 1998
Inkjet prints on canvas, installed in the
Montage Gallery, Derby, England
The West Collection, Pennsylvania, USA
Photograph by David Pearson

Opposite:
Rachel Rigby in front of *Rigby, Rachel £836.55*
Institute of Contemporary Arts, London, 1999
Photograph by George Brooks

The Arts Council of England Annual Review 1999

Developing, sustaining and promoting the arts in England

THE **ARTS COUNCIL** OF ENGLAND

This England 1998

For the Times/Artangel commissions, we proposed to build a 50 metre section of concrete 'flyover' in Green Park, London. Emerging from the trees would have been an imposing and apparently purposeful structure, a sweeping arc supported on tall piers. Yet as the viewer approached, it would have become clear that this was a fragment of infrastructure, displaced and unusable, which spanned only a hollow of gently sloping parkland.

The term 'bridge' is often used to express the concept of exchange between two parties and transition from one state to another. If these parties are seen as the worlds which lie above and below the surface – perhaps the subconscious and subterranean flows on the one hand, and the conscious actions of rational beings on the other – then *This England* might have symbolised a connection between them.

Resolutely functional in design and construction, *This England* would have been grounded in the disciplines of civil engineering and landscape architecture. With its physical form determined by the properties of its materials and the demands of the site, *This England* would have wildly celebrated the modernist faith in the civilising power of reason to improve the public sphere.

However, part of the work's aim as art would have been to tap into the collective consciousness of a buried life force. Located in relation to the former course of the buried river Tyburn, and to invisible patterns of energy such as the 'desire lines' expressed by people walking across the land, *This England* would have raised a monument to a series of contradictions.

On one level, the proposal presented a marriage of oppositions: the river as a sign for nature and the feminine, and the bridge as technology and the masculine. Yet the river is absent, perhaps even suppressed or denied, while the bridge would have been out of reach and without practical function. The work's engagement with its setting would have remained poised between an ambitious public optimism and the private melancholy of a stalled dialectic or unfinished conversation.

This England is a magazine that has been published since 1968. Its sedate photographs of unspoilt countryside and nostalgic articles on English life are interspersed with poems offering moral guidance and editorials promoting reactionary views rooted in intolerance and fear of others.

Proposed location for *This England*
The buried course of the river Tyburn,
Green Park, London, 1998

The Return of the Real 1998

We invited Mick Walker, comedian, to make a 15 minute presentation to an audience of academics at Practically Speaking, a conference on issues in art and design education at the University of Wolverhampton in December 1998.

Mick is a fascinating character with a wealth of show business experience. In the 60s he worked in various bands such as The Redcaps playing bass and gradually introducing his own brand of stand-up comedy into the shows. In 1966 Mick managed Birmingham's famous 'Rum Runner Club' where he produced and presented shows with such artists as Tom Jones, The Everly Brothers, Chuck Berry and Lulu to name but a few.

In 1969 Mick formed his own Comedy Jazz Trio doing a 10 month season at the Pigalle Club in London's Piccadilly and then touring the British Cabaret Circuit. During this time, due to his long standing interest and participation in Amateur Boxing, Mick started to fit in film and TV stunt work whenever possible.

After finishing a cabaret season on the Cruise Liner QE2, which sailed from New York to the Caribbean, the trio returned to Britain whereupon Mick suffered serious injuries falling from a cliff in the North of England, and the act broke up. After six months in the hospital Mick went into the rock band management and production industry in England and Europe and eventually South America, where he spent two years based in Bogotá Columbia.

He returned to England in 1976 and began working for John Reid Enterprises as personal bodyguard for Elton John, Freddie Mercury and Kiki Dee. Mick moved to Spain's Costa Del Sol in 1982 as head of entertainments for the Pontinental Holiday Circuit. Two years later Mick moved back to England working as a stand-up comedian and doing various. TV shows for the BBC with Tom O' Connor doing comedy character parts, and working the cabaret circuit until 1987 when he returned to Spain and successfully managed various hotels and clubs. Mick is now back in Britain and is in great demand on the corporate/after dinner circuit specialising in sporting dinners.

— Jake Elcock Entertainments, South Staffordshire, England

Comedian Mick Walker
Publicity photograph, 2008
Courtesy of Jake Elcock Entertainments

Problems Solved 1999

For our contribution to Dot, a year-long cumulative art project curated by the artist Liz Price, we produced a business card.

We chose to produce this card at the time when electronic mail was beginning to displace postage as the standard means of text-based correspondence. Book Works, London, typeset the card for us in Gill Sans and printed it in letterpress on uncoated 300gsm acid-free card. The card's design and production qualities were intended to suggest an ambition for clarity and longevity in dealing with the material realm of problems (and solutions).

Using an ampersand to associate the surnames Cornford & Cross aligns our partnership with conventions of professional practice. The ampersand is a typographic ligature of the letters 'et', Latin for the English conjunction 'and'. This linguistic device denoting connection suggests that the nature of the bond between individuals is rooted in language as part of a wider and older set of codes articulating thought and governing behaviour.

As the card does not specify the nature or range of problems that might be solved, it does not constitute an offer in English law, but an invitation to treat — the implication being that interested parties should approach us in order to define the problem in question. By neither connecting nor separating the problems of art from those of any other field, the card invites people to problematise all situations, and to open discussions as to how to go about resolving them.

'Reasonable rates' anchors the ideal of the rational subject within the context of the economic. *Problems Solved* appealed to commonsense notions of value and moderation, while inviting people to rethink what constitutes the subjective, the historically specific and the ideological.

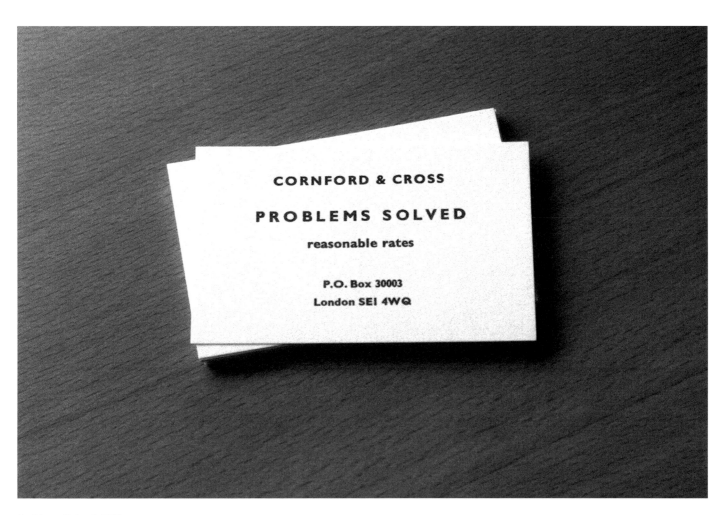

Problems Solved, 1999
Letterpress on card

Jerusalem 1999

Jerusalem was a unique sculptural work for EAST International, positioned on the playing field of the King Edward VI School by the river Wensum, Norwich, England. The sculpture was a life-sized figure of a military cadet based on a Norwich schoolboy, standing to attention and bearing an SA80 assault rifle. We paid a local artisan to cast the figure using lead from spent bullets which we gathered from the shooting galleries of the National Rifle Association. Casting this figure may have suggested a relation between the process of education and that of moulding; using lead referred to the toy soldiers of another age, and related base metal to the intangible ideals of duty and self-sacrifice.

The figure was displayed on a plinth of stone from Caen in Normandy, and inscribed by the monumental mason of Norwich Cathedral with the single word "Jerusalem". As the raw material of cathedrals and castles since the Norman conquest, Caen stone has long been imbued with symbolic authority from the feudal period in English history, when the power of Church and State were joined. During the Second World War, Caen was devastated by Allied bombing in the preparation for D-Day and the liberation of France. After the War, the city was rebuilt using the local stone.

Following the French Revolution, William Blake's poem "Jerusalem", 1804, offered a visionary critique of militarism and empire-building, yet over time it has become a patriotic English anthem. The city of Jerusalem has for thousands of years been a sacred destination for pilgrims of three faiths, both fought over and cherished as a source of spiritual redemption. Set in the peaceful and quintessentially English scene of the public school grounds, the leaden figure of a boy soldier stood facing west in an open space of well-tended turf, bounded by mature trees and crowned by the spire of Norwich Cathedral.

Associations between conduct on the playing field and on the battlefield have been given historic importance as enduring values in British national identity. Even today, these values relate to metaphoric connections between fighting for the conquest of evil and the defeat of an enemy.

Deirdre Grierson
Gift card showing Norwich Cathedral and
King Edward VI School, Norwich, England

Above:
John Tweed
Rifle Brigade 1914–1918 War Memorial, 1920
Grosvenor Gardens, London, 1999

Above right:
Toy soldier
William Britain Limited, 1999

Right:
British soldier with SA80 assault rifle
Army firing range
Bisley, Surrey, England

Below:
Spent bullets gathered from National Rifle
Association firing range
Bisley, Surrey, England, 1999

Opposite:
Ferry to Caen, Normandy, France, 1999

Left:
Quarry of the Atelier Lefèvre,
Caen, Normandy, France, 1999

Below:
Monumental mason of Norwich Cathedral
inscribing Caen stone plinth
King Edward VI School, Norwich,
England, 1999

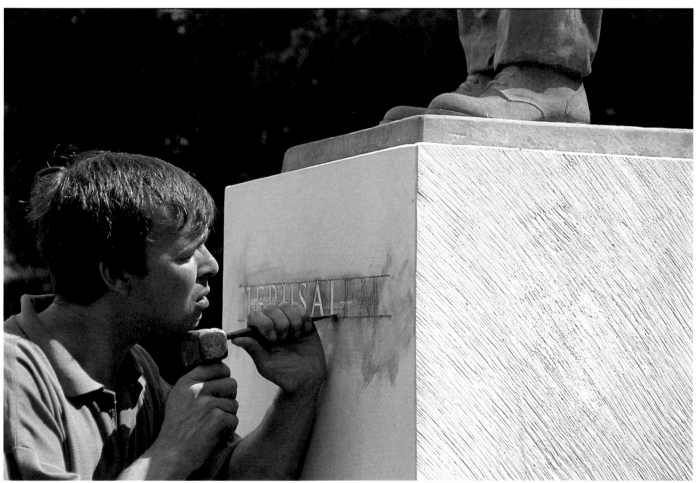

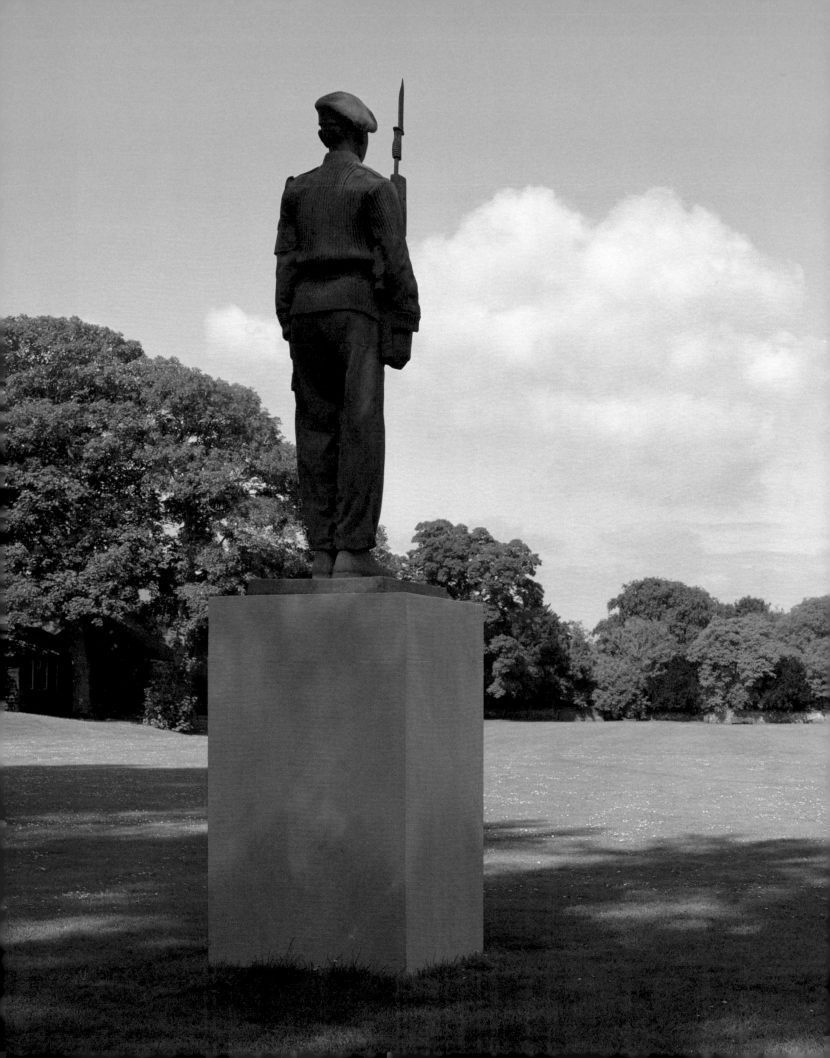

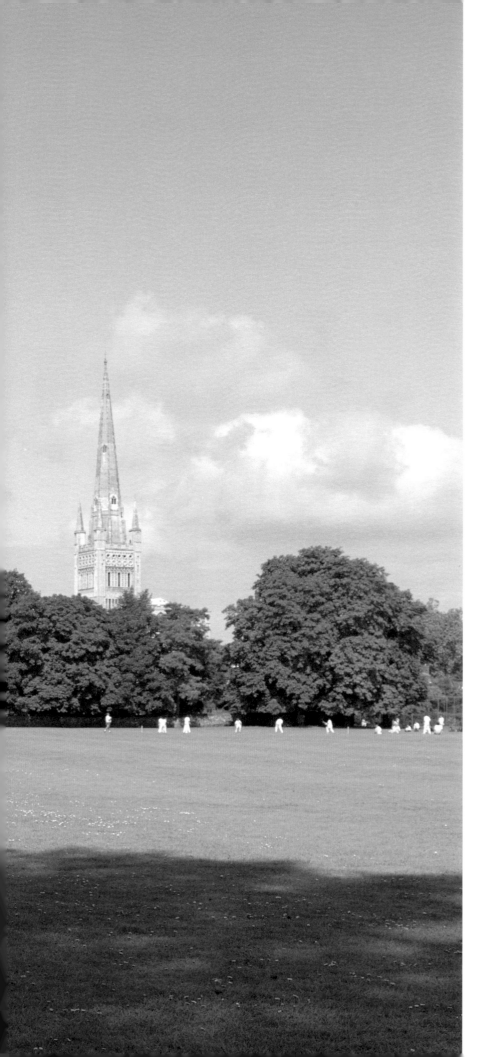

Jerusalem, 1999
Statue cast from bullet lead, Caen stone plinth
King Edward VI School, Norwich, England

Cornford & Cross destroyed the statue and
plinth in 2002

Utopia 1999

Bournville once offered a model of economic and social relations based on Quaker values, 'benevolent patriarchy' and the enforced stability of the British Empire. The codes of conduct have gone which for many years governed relations between the men and women who worked for Cadbury, although the gendered division of space is still clearly visible in the architectural detail and the designation of areas for work and leisure. Today, the territory between Bournville train station and 'Cadbury World' is marked out with Cadbury's corporate purple on signs, doorways, lamp posts and railings.

On our first visit, we became interested in the large ornamental pond which had been the focus of George Cadbury's 'Women's Recreation Ground' in the period when the Suffragettes used purple to identify their movement. In spite of its location in an architectural conservation area, the pond had suffered years of neglect; it had been drained and was being used as a tip for garden and builders' waste. We learned that the pond was scheduled to be filled in and turfed over.

We arranged for the pond to be repaired, the paved surround to be replaced with newly quarried stone, and new fountains to be installed. Cadbury's filled the 37,000 gallon pond for us by diverting the water supply from their factory one night. We worked closely with Cadbury's chief food scientist to formulate and produce a liquid solution of food-grade purple dye, which the scientist poured into the pond for us. Although it was non-toxic, the dye blotted out the light, preventing photosynthesis in a suffocating extension of the corporate identity. The water in the pond grew dark, translucent so that it was impossible to judge its depth, and reflective so that its surface mirrored the surrounding garden and the viewer.

In spite of these reversals, *Utopia* played the part of a high profile 'gift' to Cadbury Schweppes which was popular both with their employees and with the public. This drew the company into a situation whereby the antique pond — symbol of old-time philanthropy which was about to have been destroyed and erased in a cost-cutting exercise — could not quietly disappear without considerable loss of face. To a corporation poised between the pressure to conserve its historic tokens of benevolent paternalism, and the demands of its shareholders in today's globalised 'free' market, we hope this may have given pause for thought.

Bournville Village, Birmingham, England, 1999

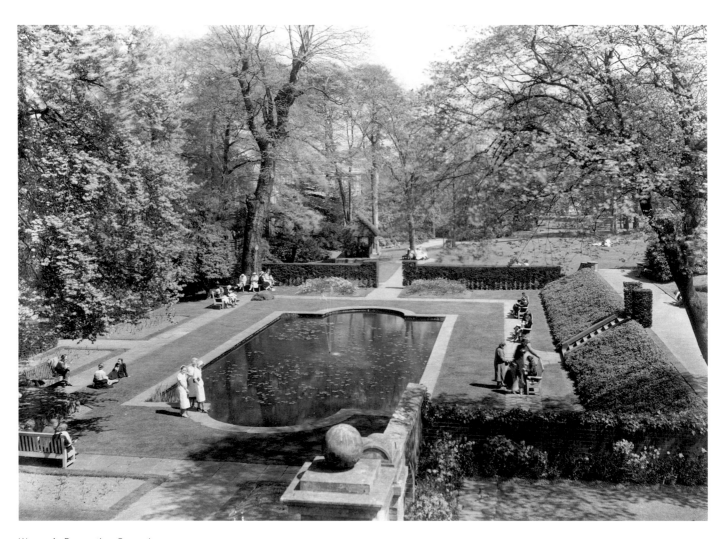

Women's Recreation Ground
Bournville, Birmingham, England, 1936
Courtesy of Cadbury's Archive

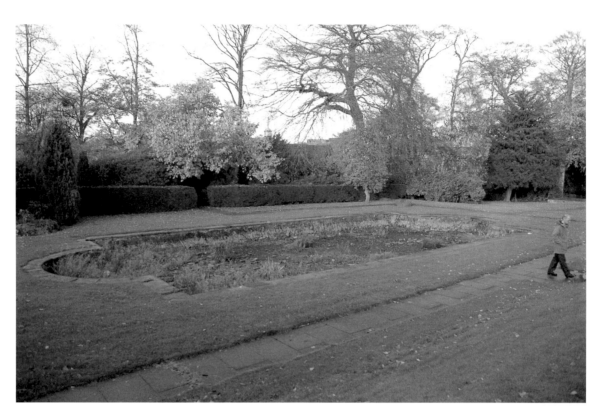

Above:
Curator Gavin Wade in the Women's Recreation
Ground, Bournville, Birmingham, England, 1998

Right: Cadbury's 'Dairy Milk' logo, 1998

Left:
Source of new paving for pond
Woodkirk stone quarry
Leeds, Yorkshire, England, 1999

Centre and below:
York stone paving being laid and final
adjustments being made
Women's Recreation Ground,
Bournville, Birmingham, England, 1999

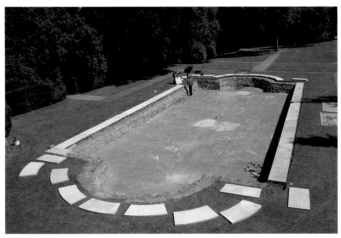

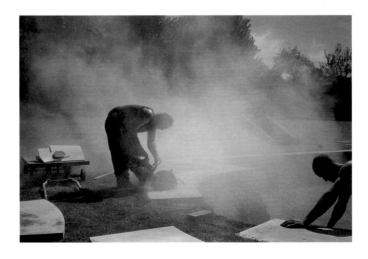

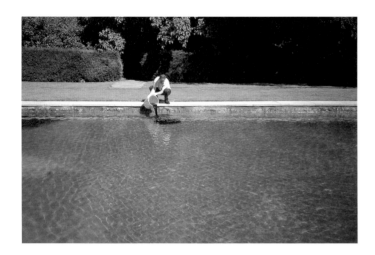

Left and below:
Cadbury's chief food scientist
pouring food dye into the restored pond
Women's Recreation Ground,
Bournville, Birmingham, England, 1999

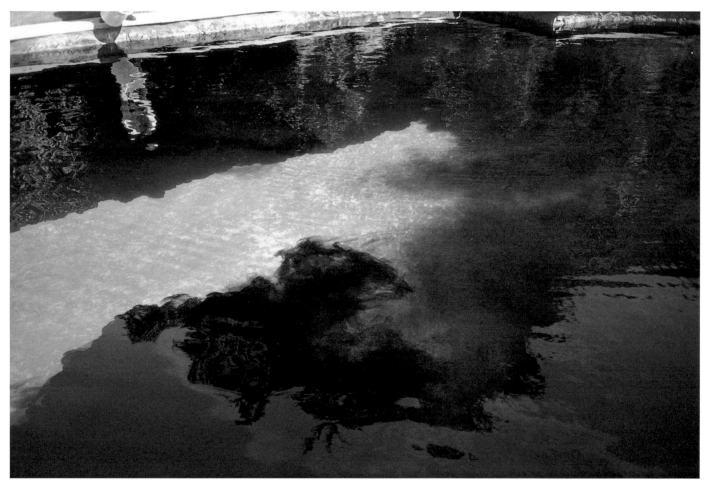

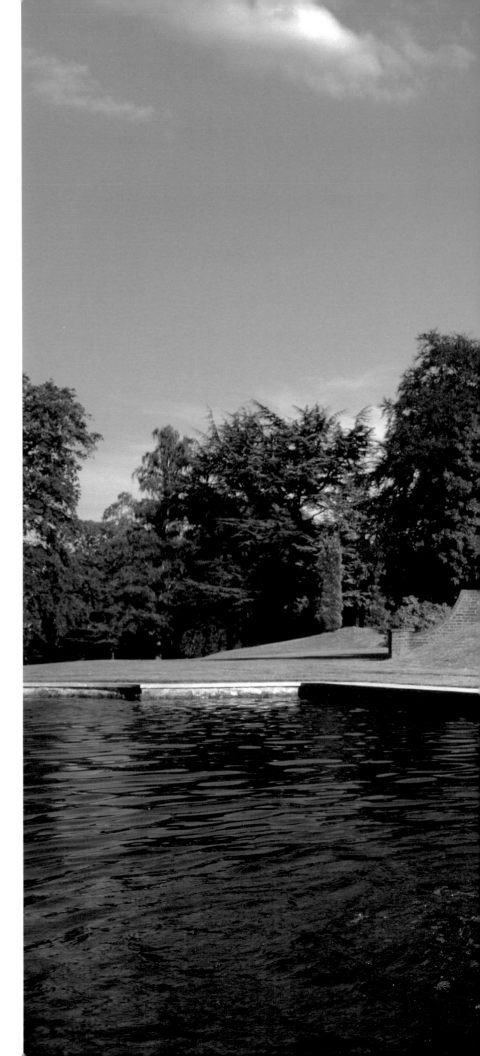

Utopia, 1999
Restored ornamental pond, food dye, fountains
Women's Recreation Ground,
Bournville, Birmingham, England

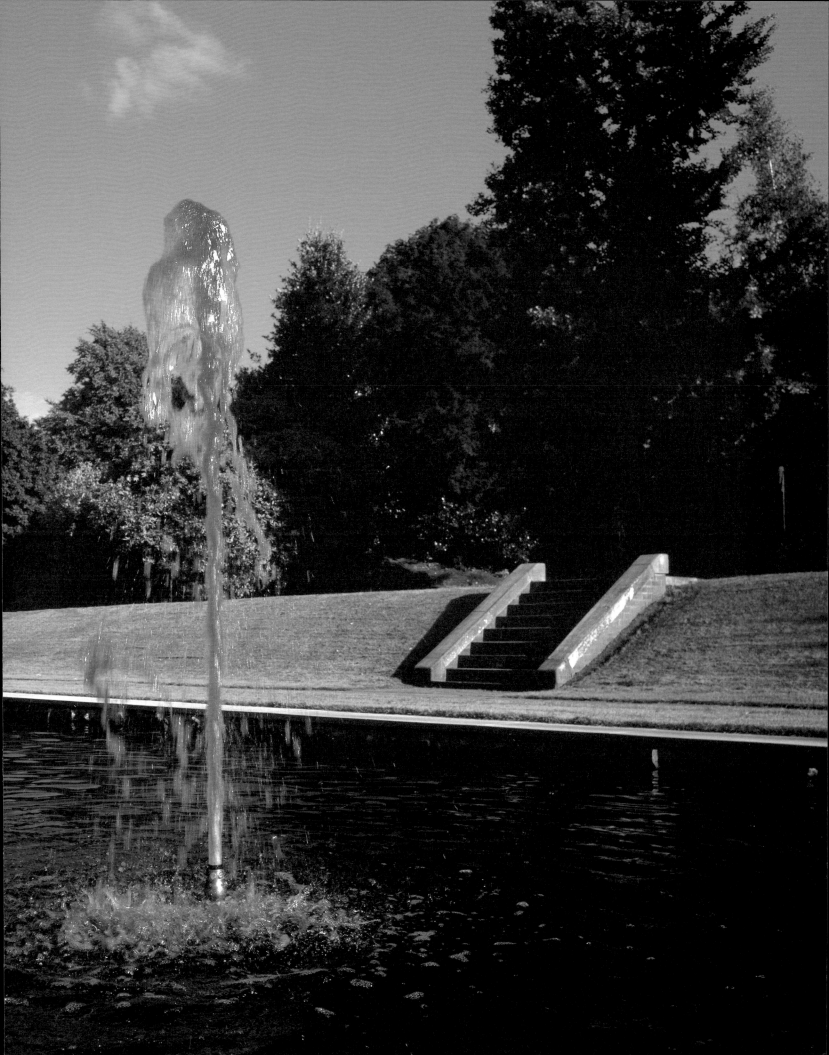

Art School 1999

Art School would have occupied the Chisenhale Gallery, London, for one month to facilitate an explicit and implicit enquiry into notions of the art school.

With contributions from artists, writers and curators, the project would have encouraged participants to bring together rational and intuitive modes of thought, across the widest range of activities. These activities would have been contextualised through presentations, debates, and critiques.

One aim of the proposed project was to establish conditions for productive encounters of social difference, which we hoped would have carried over after class and beyond the event.

As a brief respite from some of the problems that face art education in Britain, *Art School* would have combined high artistic and intellectual ambition with freedom from assessment criteria, managerialism, audit culture and marketing.

Participation in *Art School* would have been free; materials would have been basic, and the contributors would have been paid a reasonable fee. To pay for the project, we would have bid to the Research Committees of the new Universities in which we worked, for Research Assessment Exercise funds.

MA Fine Art studio, School of Art & Design,
University of Wolverhampton, England, 2008

Childhood's End 2000

We commissioned a pilot and chartered a privately owned jet aircraft to draw the Anarchy symbol with smoke in the sky. This was filmed from a 16mm cine camera mounted on the weapon platform under the left wing, and from a miniature video camera inside the cockpit. The duration of the piece is about six minutes, being both the length of time taken to complete the manoeuvre and the length of one uncut roll of film. The film and video material from this performance was transferred to DVD for exhibition as a spatial installation within the gallery.

Aerobatic displays apply the skills and manoeuvres developed for aerial combat to create public spectacles; the demonstration of technological power and technical prowess serves to pre-empt critical thinking and popularise militarism.

Cinema has rich associations with conceptions of utopia: the medium depends on and fuels people's desire to be mentally 'transported'; it offers dramatic possibilities to explore utopian and dystopian alternatives to existing social conditions, and it plays on the tensions between individual and collective fantasy. Flying and filming have been historically bound up with militarism on many levels, from the development of related gun and camera technologies to the strategic and cultural implications of new ways of seeing space and movement.

Inscribed by a fighter jet on the optimistic space of blue sky, the ambiguity of the Anarchy symbol is heightened, its utopian ideals of universal understanding and autonomy becoming enmeshed with the implied threat of violence. Simultaneously, the order and discipline of a militaristic activity is co-opted into displaying the transgressive impulse that lies beneath its urge to destroy.

The gallery installation consists of two screens facing each other so they cannot be held in the same field of vision; they offer images of confinement and exposure, which though joined are never reconciled.

Childhood's End, 1953, is the title of a novel by Arthur C Clarke, which envisions a future where humanity undergoes the loss of innocence or the attainment of maturity, and becomes subject to forces that acknowledge no distinction between 'good' and 'evil'.

Film technician meeting flight engineer
Cranfield air base, Bedfordshire, England, 2000

Above:
Model kit box
Airfix Hobby Products Group, England, 2000

Right:
Cover to paperback of *Childhood's End*
Pan Books Ltd, London, 1956

Childhood's End, 2000
Gnat jet passing overhead
Cranfield air base, Bedfordshire, England

Childhood's End, 2000
Digital video still from two screen video installation
duration 6 minutes 9 seconds
Collection of Wolverhampton Art Gallery, England

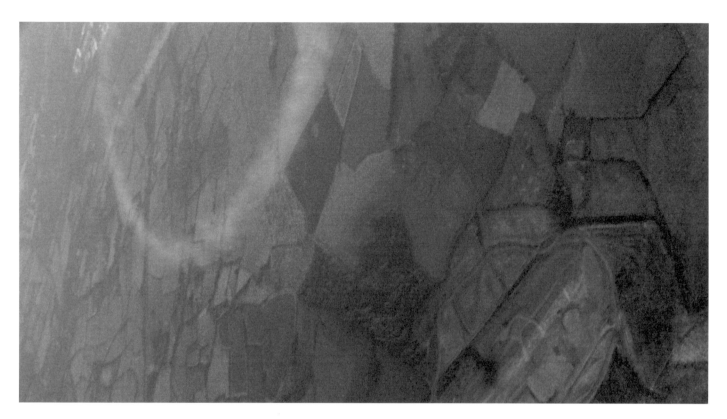

Childhood's End, 2000
16mm film still from two screen video installation
duration 6 minutes 9 seconds
Collection of Wolverhampton Art Gallery, England

The End of Art Theory 2001

We were invited to submit proposals for the 2002 Liverpool Biennial. We proposed to commission a Group 4 private security vehicle and uniformed crew, as used by HM Courts and Prison Service to transport defendants. During the Biennial, visitors would have been encouraged to be locked in the cells inside the vehicle, which would then have gone on a 'free' tour of the cultural institutions and public artworks included in the Biennial.

The daily presence of the security vehicle at cultural venues might have highlighted the association between authority and power. While inside, the viewing subject would have become an object of enquiry to passers-by. Our project, *The End of Art Theory*, aimed to engage participants directly in a social and spatial experience intended to appeal to the senses as much as the intellect. Entering the enclosed space would have been an act of voluntary self-denial, similar to that made by the ascetic aspiring to a higher state of consciousness or by the prisoner of conscience as a statement of protest. Uncertainties might have arisen concerning the relationship between self-discipline and the rule of law. Equally, turbulent parallels exist between the notoriety of certain transgressive artists and the charisma bestowed on some criminals through media attention.

We would have also produced a series of portraits of the participants by photographing through the tinted windows of the security vehicle while they were being transported through the city in confined isolation.

The End of Art Theory: Criticism and Postmodernity, 1986, is the title of a book by Victor Burgin, who "refuses to think 'art' in isolation from the political, or to conceive the 'political' in purely socio-economic terms, without a theory of the unconscious".

Logotype for the Liverpool Biennial, 2002

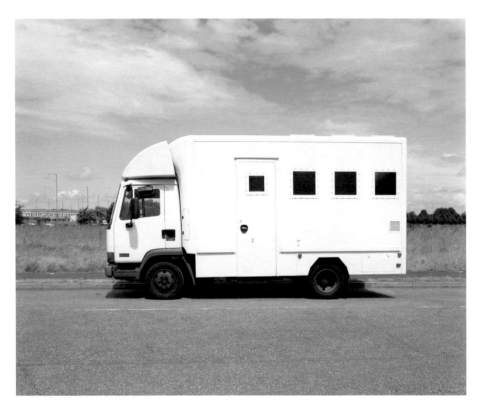

Above and opposite:
The End of Art Theory, 2001
Exterior and interior of Group 4 private
security vehicle

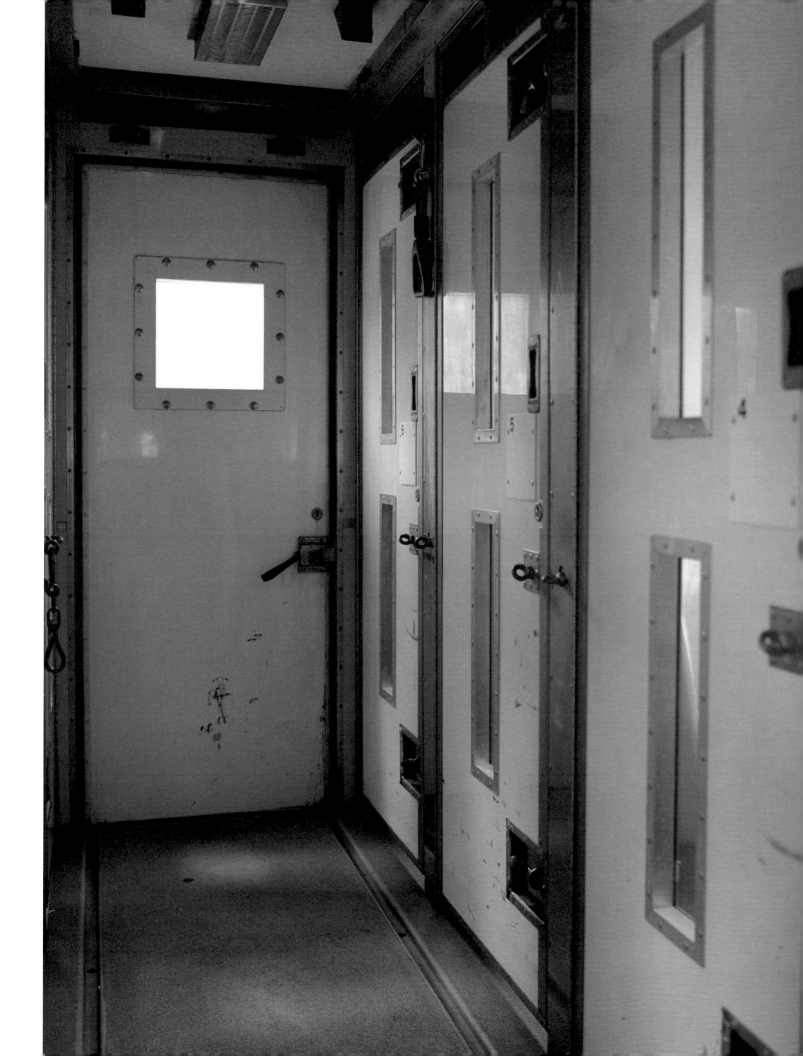

The Ambassadors 2001

We were invited to submit proposals for the 2002 Liverpool Biennial. Our proposal, titled *The Ambassadors,* would have consisted of a set of flags of those nations with which HM Government did not maintain diplomatic relations. The flags would have flown from the flagstaffs on the Cunard Building by the river Mersey, near the Tate Gallery and the Pierhead, which has a history as a site not only of arrival and departure, but also of public debate and demonstration.

We wrote to the United Kingdom Foreign and Commonwealth Office in July 2002, who informed us: "There are indeed only two states which Her Majesty's Government recognises, but with which it does not have diplomatic relations. These are Iraq and Bhutan. Iraq severed diplomatic relations with the United Kingdom in February 1991. There are no relations with Bhutan for administrative reasons, rather than reasons of disapproval. [...] We have trade and cultural offices in Taiwan, but do not recognise the state."

Had our proposal been accepted, we might have acquired the flags through correspondence and negotiation with representatives of the nations concerned. We hoped, through a process of diplomacy, to obtain in each case official statements on the current situation.

We were equally interested in having the flags made in Liverpool by paying people on a piecework basis. Many such textile workers are women working from home, perhaps within immigrant communities. By 'outsourcing' production in this way we might have invoked the deregulated labour relations of the globalised economy, while making visible a symbolic connection between the domestic environment and the public sphere.

As part of Liverpool's international art biennial, *The Ambassadors* aimed to associate economics, politics and culture in a gesture of temporary but unconditional reconciliation.

In choosing the title *The Ambassadors*, we were referring to the painting by Hans Holbein. *The Ambassadors*, 1533, portrays two courtiers of the Tudor period, surrounded by objects symbolising their status and function in the emerging international political and economic geography at the beginning of the rise of the nation state.

Hans Holbein the Younger
The Ambassadors, 1533
Courtesy of the National Gallery, London

Proposed location for *The Ambassadors*
The Cunard Building, Pierhead, Liverpool,
England, 2001

Coming up for Air 2001

Coming up for Air was a proposal for a temporary public art project based on the production of an imposing landmark in the reservoir of Chasewater Country Park, Staffordshire. The project aimed to promote debate on the relationships between art and history, especially the changing connections between economic activity and representations of landscape. As the work was proposed for Chasewater, and it could only have been realised through the democratic planning process, it would also have raised issues of geography and politics, from a regional to a global level.

We proposed to build a large industrial chimney, cylindrical in form, perhaps made from smooth, pale concrete, and very plain as to detail. The scale of the chimney would have been informed by current public health decision-making processes, taking account of the type and quantity of emissions, the physical geography of the location, and the distribution and density of settlements in the fallout area.

The 'Black Country' landscape was defined in the late eighteenth century by coal-mining, iron-smelting and canal-building. After centuries of deforestation and coal-mining, the valley in Cannock Chase was dammed and flooded in 1797 to create the reservoir now known as Chasewater. This was a time of radical change from an agricultural to an industrial way of life, and in relations between the people who owned natural resources and the people who made them into commodities. From the outset, coal-mining transformed the landscape and began industrial society's dependence on fossil fuel, which continues to drive the consumerist ideology today.

Coming up for Air contrasted with the Romantic tradition of the architectural 'folly' in the landscaped grounds of an English country house. Standing directly in the waters, the sculpture would have been poised between suggestions of submersion and re-emergence. The object and its silhouette, shadow and reflection might have brought together ideas of permanence with change, and perhaps operated as a metaphor for both loss and discovery.

Coming up for Air, 1939, is the title of a novel by George Orwell, whose writing reached across class divisions – in this case to warn against the dangers of complacency, narrow materialism and short-term thinking. The novel centres on the narrator's journey through the modern landscape of England, to re-visit a pond, which for him had come to symbolise a lost paradise of youthful optimism and pristine nature.

1:25,000 scale map of Chasewater, England
reproduced from Ordnance Survey with the
permission of Her Majesty's Stationery Office
Crown Copyright 2001

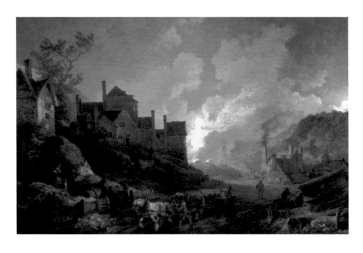

Left:
Phillip James de Loutherbourg
Coalbrookdale by Night, 1801
Courtesy of the Science Museum, London

Centre:
Miner Drilling for Blasting, 1916
Courtesy of Imperial Publishing Ltd

Below:
An Environment Agency Officer leads a man
from the floodwater at Bewdley, where the
River Severn has burst its banks, 1998
Courtesy of News Team International

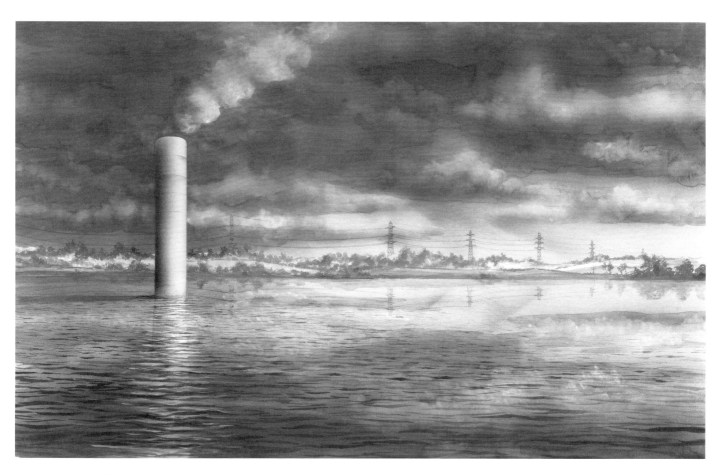

Coming up for Air, 2001
Artist's impression by Robert G Lloyd
Collection of Daniel Brooke

How Buildings Learn 2001

The first version of this project was installed in Let's Get To Work at Susquehanna Art Museum, Harrisburg, Pennsylvania, USA, in 2001. In 2004, we re-made this work with different material for the 11th Biennial of Visual Arts in Pancevo, Serbia and Montenegro.

In the public archive of Pancevo we shifted and re-arranged documents and files, to completely block a doorway. The archive material spanned a hundred years and more — wax-sealed and worm-eaten ledgers; legal texts in German; long-forgotten fiscal and financial transactions; medical records of injuries and illnesses; Communist Party membership cards in faded files detailing the minutiae of people's lives. Yet what was missing from the mass of material was any record of the decade-long ethnic war in former Yugoslavia.

To make the installation we used the documents and files as building blocks, arranging them in layers according to their size and shape. This made their contents inaccessible, and rendered them unusable as a historical resource. Their physical mass created a literal blockage within the building that deliberately confounded the ordering principle of the archive through an act of controlled nihilism.

As stores of information, archives can either threaten or entrench dogmatic systems of thought. *How Buildings Learn* was an art project that relied less on the 'suppression of visuality' than on the suppression of textuality. The Chancery director Milan Jaksic showed great generosity and public spirit in allowing us to disrupt the archive to build the installation. And through their willing participation in causing a blockage in their own institution, the Chancery staff became complicit in our action.

Only the surface of the books and documents hinted at the dense mass of material, and the labour that produced it. But it was the making of the work that allowed social encounters to inform our understanding of it. Perhaps in Pancevo, *How Buildings Learn* acted as a sign: either for the futility of all effort, or for the difficult, painful work yet to be done in relating history to memory.

How Buildings Learn, 1994, is the title of a book by Stewart Brand, who proposes that the form of buildings should continually develop through the social processes that take place in them.

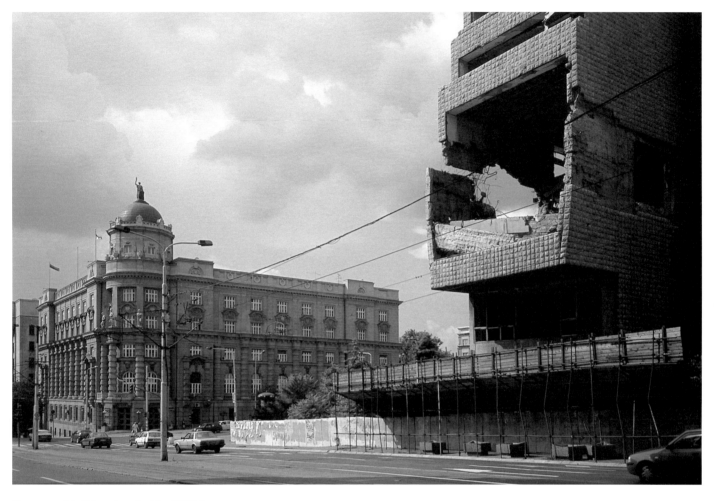

Government buildings bombed by NATO forces
during the Balkans conflict in the 1990s
Belgrade, Serbia and Montenegro, 2004

Left:
Archive of the Chancery,
Pancevo, Serbia and Montenegro, 2004

Below:
Archive material set out during the making of
How Buildings Learn, 2004 version

Opposite:
How Buildings Learn, 2004 version
Doorway blocked by archive material
The Chancery, Pancevo, Serbia and
Montenegro

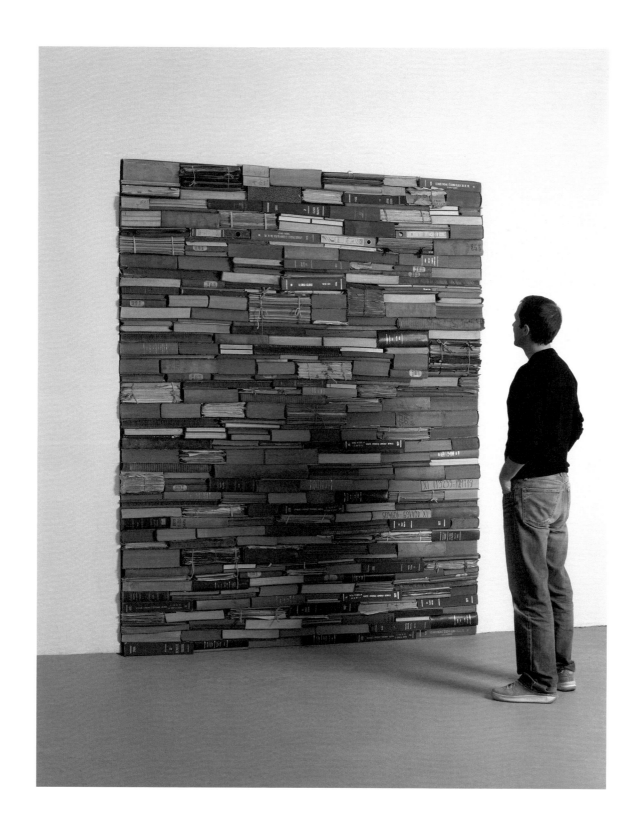

How Buildings Learn, 2004 version
Doorway blocked by archive material
The Chancery, Pancevo, Serbia and
Montenegro

Painting as a Pastime 2001

We were invited to submit a proposal for Compton Verney, Oxfordshire, England. Our proposal was to offer a single first prize of £10,000 for a national painting competition, titled 'Painting as a Pastime': an artist-organised event open to absolutely everyone! All forms and genres of painting would have been welcome, with no limit on size, and admission free. The event would have taken place over two glorious weeks of July, when the light and landscape can be at their most picturesque.

There would have been only two requirements. First, the painting must have been completed within the landscaped grounds of Compton Verney Manor House, set in the beautiful Oxfordshire countryside. Second, all entrants would agree to produce their work directly from life rather than from a photograph or other lens-based image.

The lovely grounds of Compton Verney were landscaped in the eighteenth century by the celebrated Lancelot 'Capability' Brown, whose idealisation of the English landscape produced a way of 'surveying the prospect' from a particular position. While *Painting as a Pastime* invited reflection on the relationship between painting, photography and landscape, it positively favours being artistically present in a place.

While highlighting the ideal of art as a leisure activity, the competition would have created a heightened atmosphere around it, drawing the aesthetic hobby into a materialistic, competitive situation. In offering the bulk of our production budget as prize money, we asked to exchange the role of artist for patron, and beneficiary for benefactor. By taking up the offer, members of the public would have gone beyond their role as the creators of individual artworks to become active performers in a collective artwork.

The competition would have been judged by a panel of eminent figures (HRH Prince Charles? Sir Christopher Frayling? Sir Philip King? Rt Hon Chris Smith MP? Sir David Puttnam? David Bowie? Paul McCartney? Sister Wendy Beckett?).

Painting as a Pastime, 1921, is the title of an essay by Winston S Churchill, in which he extols the virtues of painting as a regenerative activity for "the avoidance of worry and mental overstrain", if it is undertaken with sufficient focus and concentration of effort.

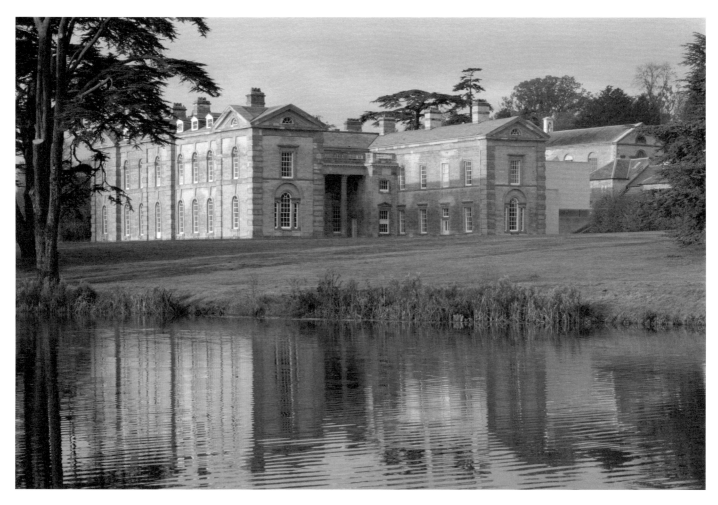

Brett Prestidge
Compton Verney, Oxfordshire, England, 2000
Courtesy of Stanton Williams Architects

The Treason of Images 2001

We were invited to submit a proposal for the Imperial War Museum, London, Commission on the Aftermath of 11 September and War in Afghanistan. We proposed to install a short section of oil pipeline in Afghanistan, somewhere along one of the intended routes linking the oil fields of Central Asia with the Arabian Sea.

The social process of this project would have encompassed the advocacy and negotiation we would have undertaken to gain approval and realise the physical part of the work. The help of Afghan people and international aid agencies, as well as the military and oil pipeline designers, would also have been necessary for the project's realisation.

Our photographs of the project would have emerged in relation to news management procedures, as we were aiming this work at the news media as well as visitors to the Imperial War Museum. As the project could only have been realised through practice legitimated as art by official cultural support, and within territory protected by military force, it would have existed as a function of influence and control.

Consumer culture has a problematic and contradictory relationship to other cultures, and to the natural environment. As finite resources become increasingly scarce, competition for them is likely to become more intense. The scale of this competition will be affected by levels of consumption, while its nature will be influenced by factors including corporate communications, diplomacy and military conflict.

Art historical precedent for the proposed work may be found in some of the American Land Art projects of the 1960s, including Nancy Holt's *Sun Tunnels* and Robert Smithson's *Non-Sites* and *Displacements*.

The Treason of Images, 1929, is the title of René Magritte's seminal painting of a tobacco pipe and the words "Ceci n'est pas une pipe". The work spans surrealist and conceptual art, and highlights the contingent nature of the relationship between language and image, between perceptions of the world and representations of it.

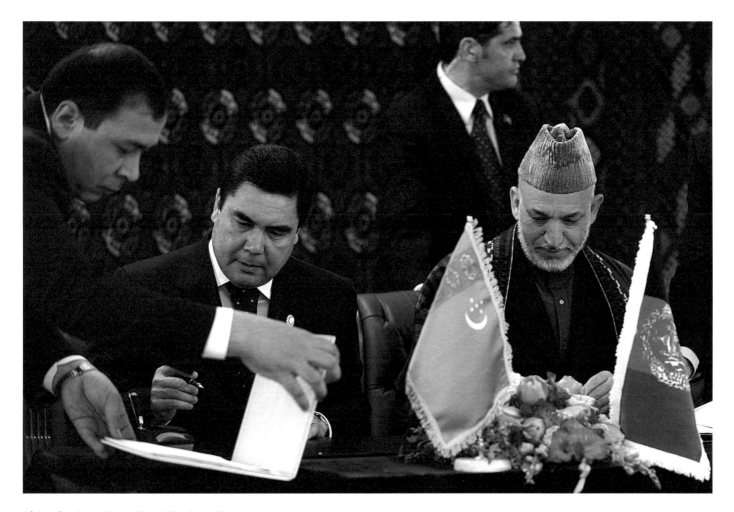

Afghan President Hamid Karzai (right) and his
counterpart from Turkmenistan, Gurbanguly
Berdymukhamedov (second left) sign deals with
Pakistan and India to push forward a multi-
billion dollar gas pipeline. Presidential Palace,
Kabul, Afghanistan, 2008
Shah Marai/AFP/Getty Images

Overleaf:
Neil Tudman
Near Herat, Afghanistan, 2001
Courtesy of Médecins Sans Frontières

Civilization and its Discontents 2001

The first version of this project was installed on the roof of Wolverhampton Art Gallery, England, as part of an exhibition titled 'Strike' in 2001. In 2004 we re-staged the work for Values, the 11th Biennial of Visual Arts in Pancevo, Serbia and Montenegro.

By signalling a call to Anarchy, we challenged the limits of political obligation, from a position of security as foreign nationals taking part in a cultural event. The flags were five feet square, in reference to Ad Reinhardt's black paintings; by flying them from cultural buildings throughout the city, we dogmatically refuted the layers of deadening negation set out in his "Art as Art" statements.

State power has often been portrayed as analogous to parental authority. Classic psychoanalysis posits that this authority is 'internalised' within the individual as the controlling, repressive force of guilt. So the individual's inner struggles may find their source or parallel in the tensions and conflicts between the citizen and the state. As artists we have been allowed some space by the state and market to indulge in transgressive symbolic gestures, which may act as a provocation and serve as a catharsis. The work also refers to the split between the philosophical ideal of Anarchy and its political associations with collapse into destructive chaos.

Civilization and its Discontents, 1930, is the title of the book by Sigmund Freud, which examines "the never-ending conflict of the claim of the individual for freedom and the demands of society".

Civilization and its Discontents, 2004 version
Black flag being installed on cultural buildings
Pancevo, Serbia and Montenegro

The Lost Horizon 2003

The Lost Horizon was a fantasy mountain landscape generated from financial data. It changed daily over one year, and was distributed as a screensaver to every computer in the London School of Economics and Political Science (LSE).

The everyday language and imagery of business is rich with metaphoric references to mountain landscapes. Yet these references carry double-edged meanings. Because they are barriers to physical progress, mountains have long symbolised escape from materialistic life to spiritual transcendence. Also, the concepts of risk and security in commerce are often visualised in images of climbers scaling the heights of an unspoilt wilderness, while mountaineering as an exclusive leisure pursuit has become an 'aspirational lifestyle statement'.

Every day for a year, American Express agreed to supply up-to-date Financial Times Stock Exchange data to be processed at the LSE using software designed for creating fantasy landscapes. Envisioning numerical abstractions in this way generated a landscape of alienation, a parallel world where reality was determined by abstraction. This digression from the work of economists and financial analysts seems playful, yet by wilfully misusing factual information it may offer insight into the relationship between socio-economic power and cultural constructions of space.

If fantasy and 'escape' enable the continuation of urban productive labour, then computer terminals offer an equally ambiguous threshold between lived experience and information space: depending on the motives of the user, the screen might equally represent a point of entry into or exit from 'the system'. Because the screensaver image is only visible when the machine is not in active use, it may correspond to a daydream.

Lost Horizon, 1933, is the title of James Hilton's fantasy of adventure and discovery in a remote continent during the last years of the British Empire. In today's age of global trade and technology, being 'lost' has different connotations: our movements can be tracked in the remotest parts of the world, while the vanishing wilderness is becoming commodified. And perhaps the tendency to conflate achievement with consumption maintains a paradox that binds unsustainable consumption to a sense of lack or loss.

South-Western Pyrénées, France, 1993

David A Hardy
Hall of the Mountain Grill, 1974
Hawkwind album cover artwork
United Artists Records

Dow Jones Industrial Average, 2000-2008
Financial market graph
Stock Charts, New York

I wandered far in lands unknown
Until I reached my earthly home
Far away I found life's dream
Drifting on a silver beam,
You'd better believe it, it's so easy to say.

Travelling twice the speed of light
Orion's stars are high tonight
The gentle madness has touched my hand
Now I'm just a cosmic man.
You'd better believe it, it's so easy to say.

You'd Better Believe It
Dave Brock

The upheaval of the market over the past several years has bred a new kind of investor — one who is more independent and hands-on than ever before. Technical analysis has risen in popularity in recent years because it provides independent investors with the tools to make informed investing decisions.

In essence, we help our users make money. By taking this tour, you are taking the first step towards understanding just how we do that. We hope you'll enjoy the tour, and that you'll soon be taking full advantage of the suite of tools and information we are so pleased to provide.

Welcome
Stock Charts

Building a New Generation of Leaders, 1997
Brochure cover
Banff Centre for Management, Alberta, Canada

Guided Meditation, 1987
Audio cassette cover
Integral Yoga Distribution, Virginia, USA

There is only one cause for all mental problems, worries and anxieties: selfishness. Restlessness of mind is caused by disappointments. Only selfishness causes unhappiness. To maintain your tranquility you must keep your mind away from duality – pleasure, pain; profit, loss; praise, blame. If you can keep your mind away from duality, you can still have ideas and perform actions, but they won't affect you. When you renounce your attachment, there is nothing to shake you. It is the feeling of possession, of clinging, that disturbs the mind.

How to Have a Peaceful Life
Sri Swami Satchidananda

At The Banff Centre for Management, our programs are *unique* in their ability to focus on your specific learning needs and aspirations. Our faculty staff members strive for *excellence* in helping you meet your personal targets. Our proven processes ensure that you will return to your organization able to make a *measurable impact* – and that comes with a money back guarantee!

Our Guarantee
The Banff Centre for Management

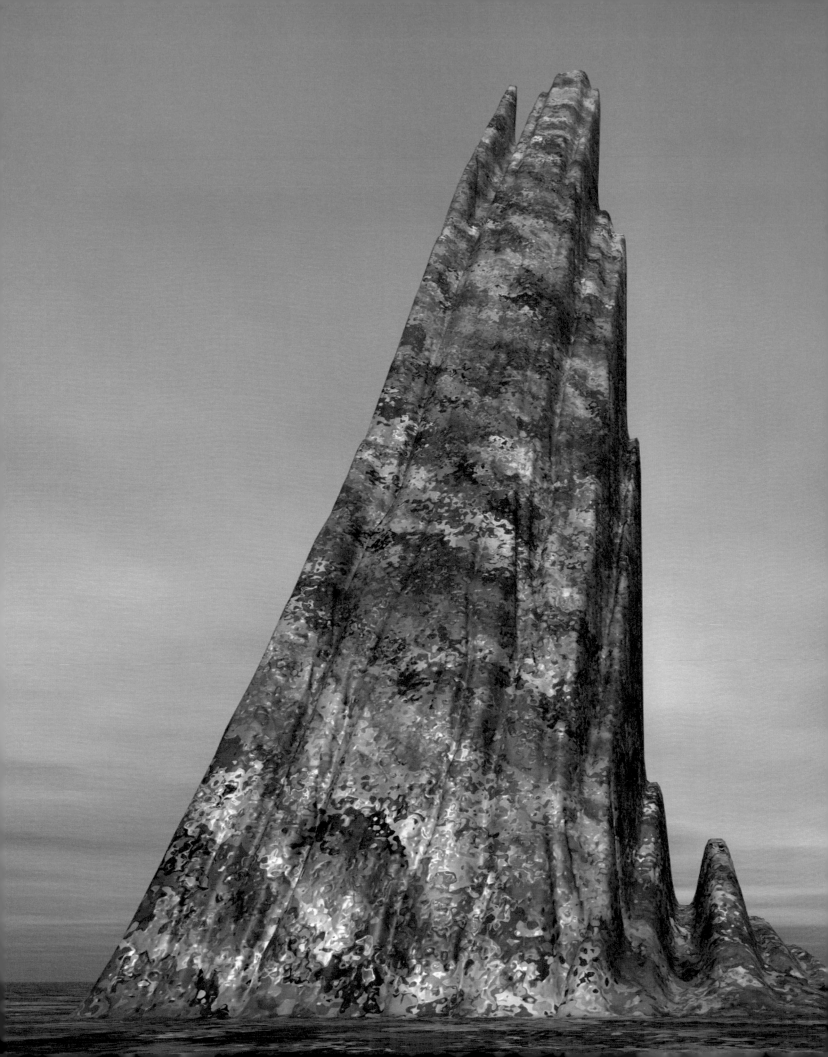

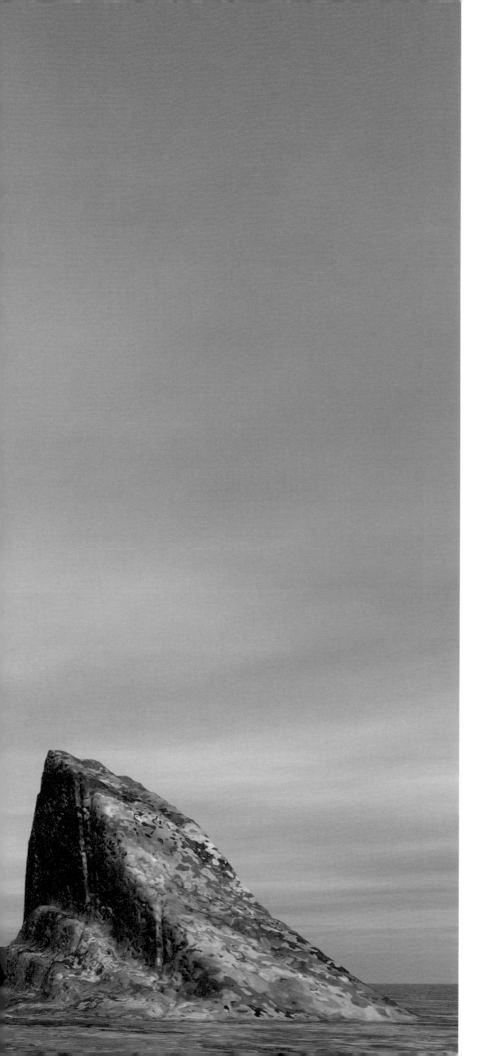

The Lost Horizon, 2004
Computer screensaver of fantasy landscape
generated from financial data
London School of Economics, London

A Month in the Country 2003

This commission called for a response to a historic photographic archive; we engaged with a contemporary archive, a stock photographic agency. We chose not to make new photographs but to hire existing ones, and then appropriate them as a way of focusing attention on their ownership and control. In commercial stock photography, the photographer produces images not for a specific commission, but to be hired out by the agency for an agreed purpose and period of time. The images are commodities, signs produced in speculation of market demand. Vast numbers of such images are grouped in generic categories, which aim to 'reflect current trends and aspirations'.

Pursuing a strategy of acquiring photographic archives and agencies, the Corbis Corporation holds over 70 million images, and is acknowledged as the world's largest collection. Corbis is owned by the richest man in the world: Bill Gates, co-founder and chairman of Microsoft.

We connected the economies of stock photography and contemporary art by using our production budget to hire the images for one month, according to the terms and conditions set by Corbis. Our picture search combined keywords for a region and a genre, 'East Anglia Landscape', which yielded just four images.

Corbis permits its clients to produce an agreed number of prints of an image, while retaining ownership and control of the image's appearance. At the end of the contracted period of one month, we kept the prints in place on the gallery wall, but whitewashed over their glazing so that the images were obscured. Thus *A Month in the Country* trapped the image within the photograph, transforming the framed prints into abstract conceptual objects.

During the Reformation, whitewash was used to obliterate wall paintings in Catholic churches, transforming them into austere places of Protestant worship. Today, an enduring legacy of modernism is the use of white walls as the defining visual statement of the contemporary art gallery. Within capitalism, the whitewashing out of shop windows has come to denote bankruptcy.

A Month in the Country, 1980, is the title of the novel by JL Carr, in which a young man attempts to recover from the trauma of the First World War. He spends his summer days in a mediaeval country church, meticulously revealing a biblical scene of damnation painted on the wall, which had been hidden by whitewash since the Reformation.

Study for *A Month in the Country*
Bankrupt estate agents' window
Cambridge, England, 2002

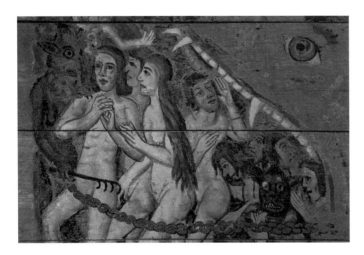

Left:
Fourteenth century 'Doom' painting
St Peter's Church, Wenhaston, Suffolk,
England, 2003

Centre:
Whitewashed wall
St Mary Magdalene Church, Withersdale Street,
Suffolk, England, 2003

Below:
Pots, brushes and whitewash
Norwich Castle Museum and Art Gallery,
England, 2003

A Month in the Country, 2003
Commercial stock photographs,
hired for one month, then
whitewashed over
Norwich Castle Museum and
Art Gallery, England

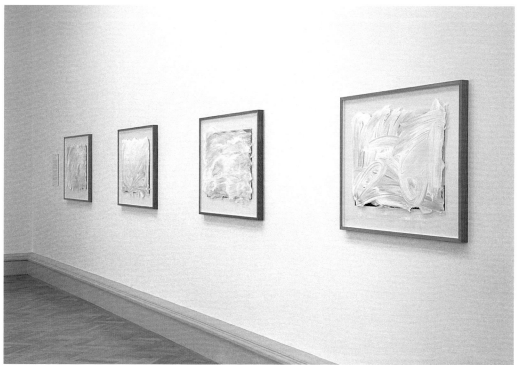

The End of History 2004

We read two books during a flight from England to China: *Confessions of an English Opium Eater*, 1821, by Thomas De Quincey, and *Youth* and *The End of The Tether*, 1902, by Joseph Conrad. Each narrative describes a journey across a physical, social and psychic landscape. De Quincey wrote in the ascendant years of the British Empire, while Conrad wrote towards, and perhaps in anticipation of, its decline.

Reading these books on this journey brought different layers of time into contact: the historical periods of the stories, the duration of the journeys described, and the passage of years between the events and their narration. As we read, the plane carried us away from Greenwich Mean Time towards the sun rising over the Pearl River Delta. It was here that China's deep culture of ancestry was brought into contact with the materialist present and invented traditions of the British Empire; with trade already degenerating into corruption, the flashpoint of the 1839–1842 'Opium War' came when Lin Tse-hsu, Imperial commissioner of Canton, seized 20,000 chests of illicit British opium, dissolved it and flushed it away into the Pearl River Delta.

We read, instead of sleeping. Altered states of consciousness and changed levels of self-awareness are central to both books: De Quincey combines autobiography with hallucination and drug-induced fantasy, while Conrad pursues scenarios and portrays his characters with a grim determination as their choices lead them to the edge of madness.

The pull towards dependence and destruction is presented in both books as an almost inevitable force. In one book this gravity produces a sense of awe at human strength, while in the other it impresses upon the reader the extent of human frailty.

The End of History and the Last Man, 1992, is the title of a book by Francis Fukuyama, who asserts that the projects of liberal democracy and the 'free market' are interconnected, and that they became complete with the collapse of communism as a viable alternative to capitalism.

City bus
Guangzhou, Guangdong Province, China, 2004

The End of History, 2004
Photograph of the site of the First Opium War
Pearl River Delta, Guangdong Province, China

She 2004

We proposed to position an eternal flame in physical and symbolic relation to the Lion statue in Forbury Gardens, Reading, England. The Lion commemorates a battle in 1880 in Maiwand, Afghanistan – Britain's last military involvement in Afghanistan before 11 September 2001. Through its monumental scale, heightened musculature and formidable pose, the Lion exudes a powerful physical presence, while retaining all the mythical and heraldic connotations interwoven with British military and feudal history.

In popular culture flames recur as symbols of destruction, passion and desire. In the public realm, symbolic flames include the torch held by the Statue of Liberty in New York, the Torch of Remembrance to the Unknown Soldier in Paris, and the Olympic flame. These invoke ideas of freedom and democracy, eternity, and internationalism.

The world's increasing dependency on fossil fuels is the key issue underlying human societies' unsustainable relationship with the environment. The proposed eternal flame would have burned mineral gas: fossil fuel piped from and across a range of territories including Afghanistan, Chechnya, Kazakhstan, Morocco and Nigeria.

The flame would have served as a beacon, and illuminated the Lion as a reference point for the people of Reading in the new world order. We think the work had strong potential for film, photography and television, and that it should have attracted national and hopefully international attention. We believe this attention would have contributed to Reading's public image as a progressive community.

The social process of gaining support and consent for the proposed installation would have involved us fully in giving public talks and presentations. We would also have consulted and collaborated with many people, including local councillors, arts officers, business people and academic researchers in the geopolitics of energy.

The flame would have burned continuously until the people of Reading exercised their democratic rights by voting to extinguish it.

She, 1887, is the title of the classic adventure novel by Henry Rider Haggard, set in a distant land at the limit of the British Empire. The central character is "She Who Must be Obeyed", a beautiful enchantress who is immortalised by immersion in the eternal flame.

The Maiwand Lion, 1886
War memorial by George Blackall Simmonds
Forbury Gardens, Reading, England
Courtesy of Reading Museum

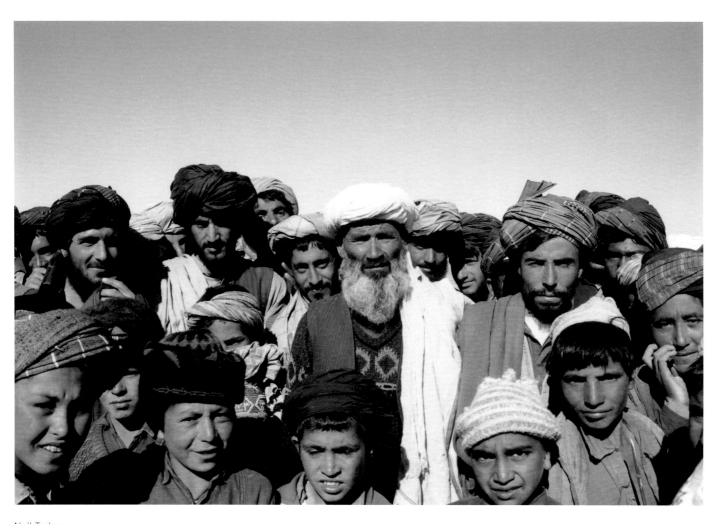

Neil Tudman
Refugees near Herat, Afghanistan, 2003
Courtesy of Médecins Sans Frontières

'Eternal Flame' study for *She*
London, 2004

Where is the Work? 2004

We removed the old grille from the heating vent set into the floor of the South London Gallery, and replaced it with a new one.

To produce the new grille, we had the old grille 'reverse engineered' by a product design company, who produced a computer-aided third angle projection drawing. All measurements on the drawing were increased by one ninety-sixth to allow for the fact that cast iron shrinks as it cools. Flaws and signs of wear in the old grille were not reproduced. We took the technical drawing to a pattern maker, who produced a three-dimensional positive model. We delivered this pattern to an iron foundry where it was pressed into sand to create a mould from which the new iron grille was cast.

So the new grille is not the result of a simulated re-enactment of the original casting process, nor is it an identical replica. It is neither better nor worse than the old grille.

The investment of time, labour and resources is 'invisible'. The new grille remains as a functional part of the architecture of the South London Gallery, while the old grille is part of the Gallery's permanent collection.

South London Gallery, 2003
Courtesy of South London Gallery

SECTION A-A SECTION B-B

Opposite:
Reverse engineering drawing of floor grille
Curventa Engineering Ltd, London, 2004

Right:
Preparing the mould for casting
Whitton castings, London, 2004

Centre:
Casting the grille

Below:
Preparing to break the mould

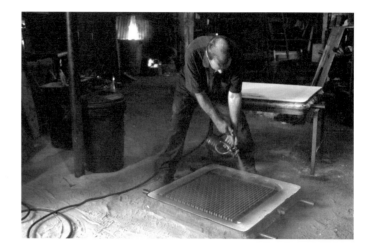

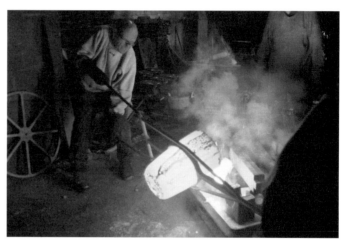

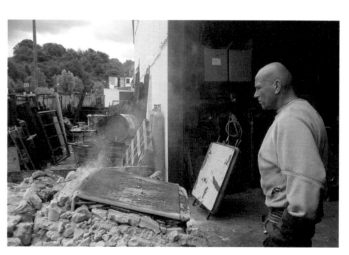

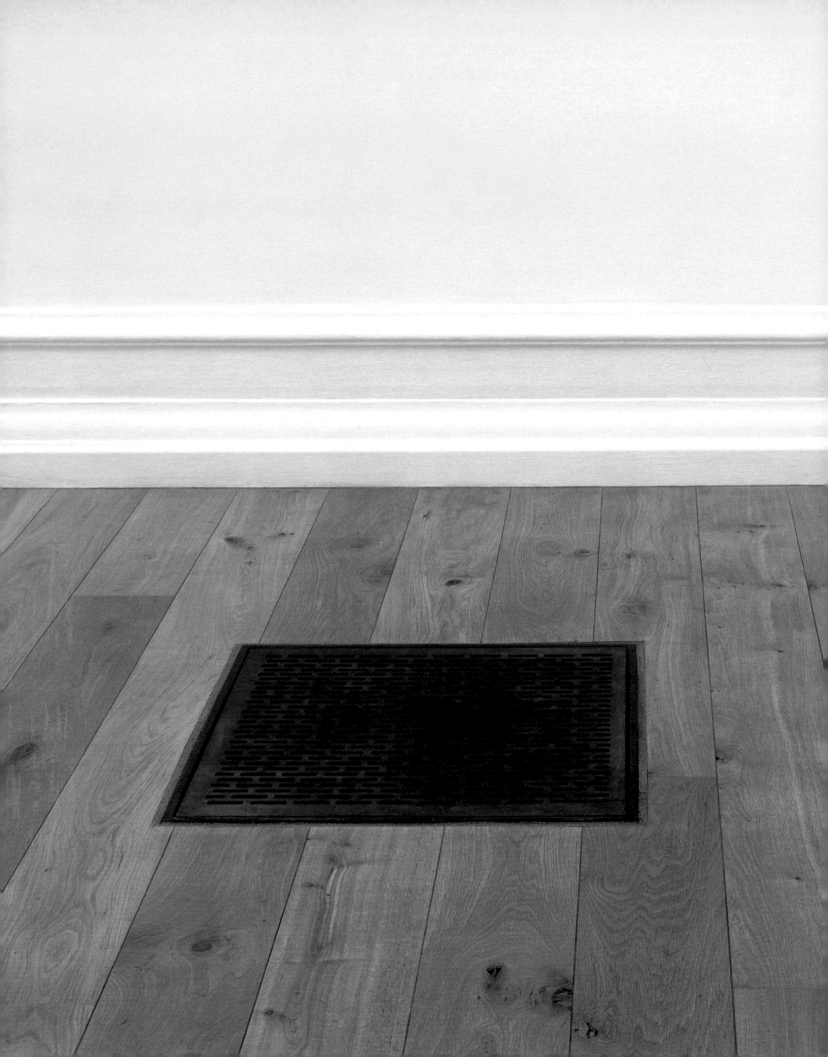

Where is the Work?, 2004
Replacement cast iron grille installed
in the South London Gallery
Collection of the South London Gallery
Photograph 2008

Why Read the Classics? 2005

Why Read the Classics? was a work made around a damaged classical statue in a public garden in Rome. A flight of stone steps leads past ancient ruins up to palms and orange trees, in a garden which, though beautiful, was rather used and neglected. Near the top of the stairway stands the marble figure of a young woman, on a pedestal in an alcove in the wall. As with so many statues in Rome, the head of the figure is missing.

Behind the space of the figure's head we positioned a golden disc, of the kind used to reflect light onto the faces of actors and models. Opposite the figure we installed a powerful film and television lamp, so that its beam of light reflected from the disc to create an aura or halo.

Visitors to the garden found their gaze drawn by the dazzling light to the iconic vision of a mythical woman. While this suggested a poetic relationship between the fragment and its setting of loss and decline, the lamp and electrical cables that produced the light anchored the scene firmly in the moment.

In *Why Read the Classics?* three conceptions of femininity converged: the classical goddess, the Christian Madonna, and the contemporary film star. Depending on the viewer's position, their co-existence in the moment may have focused the mind on issues around the representation of gender, or contemplation of the wider ideological mechanisms of belief.

Why Read the Classics?, 1978, refers to the book by the writer Italo Calvino, who answers his own question with characteristic wit and erudition.

Headless marble statue seen from the gardens
of the Villa Aldobrandini, Rome, Italy, 2005

Gardens of the Villa Aldobrandini,
and headless marble statue
Rome, Italy, 2005

Left:
Lighting and reflector test at
Panavision Italia, Rome, Italy, 2005

Below:
Installing *Why Read the Classics?*
Film lamp, reflector on marble statue
Villa Aldobrandini, Rome, Italy, 2005

Opposite:
Why Read the Classics?, 2005
Film lamp, reflector on marble statue
Villa Aldobrandini, Rome, Italy

Below:
Laura Gambarara dazzled by the light
Villa Aldobrandini, Rome, Italy, 2005

Fire Down Below 2007

At the time of this project, Aspex Gallery was being relocated to the Vulcan Building, a grand eighteenth century navy warehouse scheduled as a historic monument. To meet requirements for an education space, disability access, cafe and shop, radical architectural changes were being made.

The principal change was covering the original flagstone floor with smooth concrete. This raised the floor level, so the magnificent exterior doors could no longer be opened.

With one length of red silk ribbon we marked out key elements of the geometry of the arched doorway. This elegant archway is based on principles established by the ancient Greeks, when grammar, logic and rhetoric, mathematics, geometry, music and astronomy were developed in close relation to each other.

The arch is a semicircle, an intersection of material experience and conceptual thought. Imagine a square with its base centred on the radius of the semicircle. Where the radius touches the base, draw perpendicular lines upwards. Extend the top of the square as a horizontal line, till it touches these perpendiculars to complete a root five rectangle: the height is taken to be a unit of one, and the length is the square root of five. The square plus one of the adjacent rectangles is a Golden Section, an aspect ratio in which "the smaller part is to the larger as the larger is to the whole".

Held up for centuries as the paragon of universal harmony, the Golden Section was widely used in architecture, art and craft, including the Parthenon, Leonardo Da Vinci's painting of the 'Last Supper', and the curve of a classic ship's anchor. Right triangles within the Golden Section give rise to the 'whirling square' construction and the logarithmic spiral structure found in nature at every order of magnitude, from sea shells to hurricanes, the relative positions and movements of the planets, and the spiral galaxy of the Milky Way.

Fire Down Below, 1989, is the final novel of William Golding's *Sea Trilogy*, which follows an epic sea voyage in the last days of sail. A momentous struggle unfolds between an experienced mariner and an enterprising officer, in which hope, tempered by patience and rectitude, collides with a sense of adventure born of curiosity and self-regard.

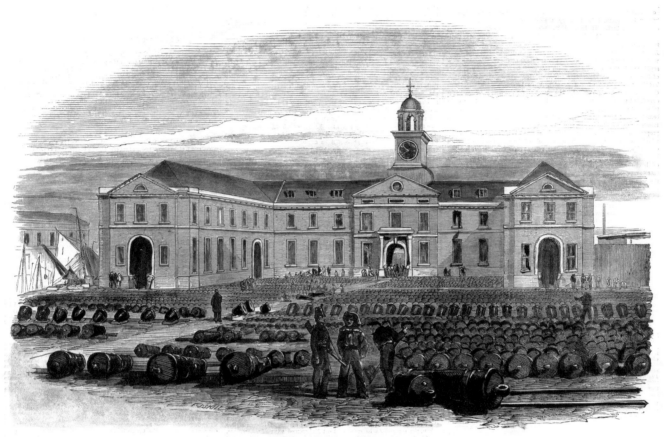

THE GUN-WHARF, AT PORTSMOUTH.

FJ Skill
The Gun-Wharf, at Portsmouth, 1855
Illustrated London News
Courtesy of Portsmouth Museums
and Records Service

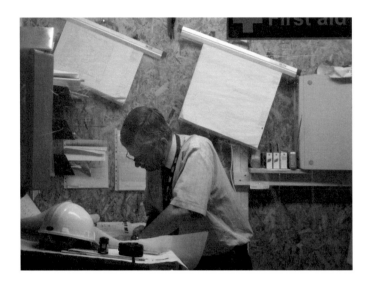

Left:
Project Manager in the Site Office
The Vulcan Building, Portsmouth, England, 2006

Below left:
The original stone floor

Below:
Raising and concreting over the floor

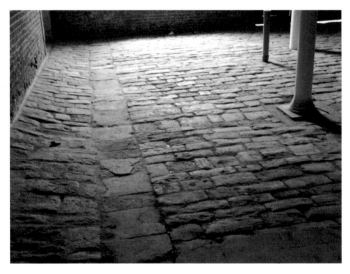

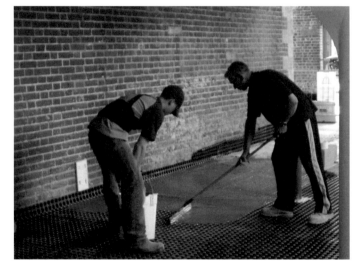

Service area doorway with air
extraction unit
Aspex Gallery, the Vulcan Building,
Portsmouth, England, 2007

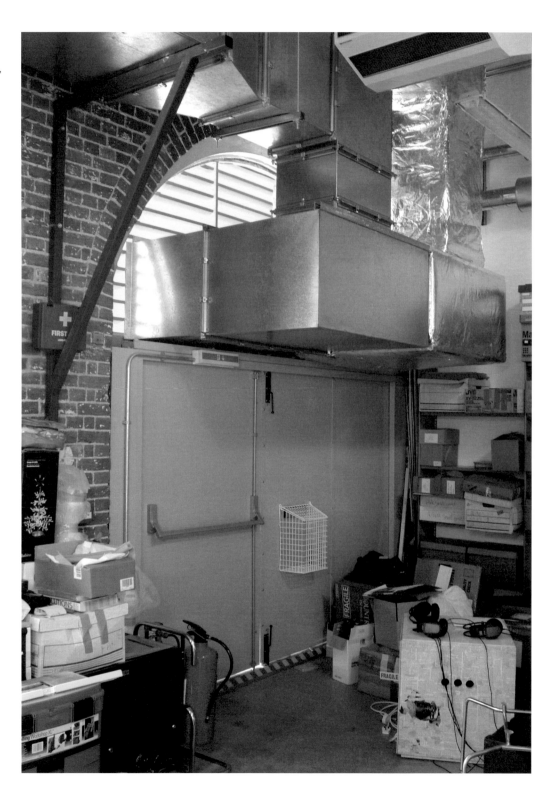

Construction of Golden Section proportions
of the door to the Vulcan Building,
Portsmouth, England, 2007

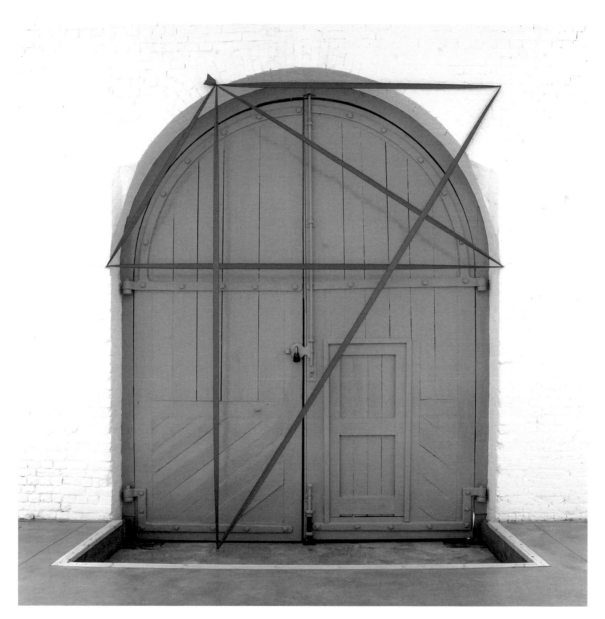

Fire Down Below, 2007
Doorway geometry in silk ribbon
Aspex Gallery, the Vulcan Building,
Portsmouth, England
Photograph by Isabella Pitisci

Words are not Enough 2007

In a vacant plot of land, a shaft drops down to a concrete stairway leading into deep shadows. A corridor gives onto a network of flooded chambers echoing with the sound of dripping water. Power generators, an air filtration system, communications equipment, maps, charts and plans are still in place, but obsolete, decaying and forgotten in total darkness.

Built to accommodate council staff in the event of a nuclear attack, the bunker is a relic of the Cold War era. Today, as an astonishing economic regeneration gathers pace in Southwark, the land stands ripe for development in this most dynamic and promising area of the capital.

To recall the time when the world lived in the shadow of a nuclear holocaust, and to question the idea of closure, we created a temporary peace garden over the entrance to the bunker. The installation consisted simply of three trees, one palm, one laurel and one olive.

Clearly, attempting to symbolise a universal, lasting peace would be to deny reality and court failure. Instead, *Words are not Enough* posited a contingent, temporary peace, located on the threshold of credibility. We kept the trees in their plastic transit tubs to emphasise their status as commodities, to heighten the temporary, contingent nature of the garden and of the peace it symbolised.

If words are not enough, then action is required. But what, and by whom? The project aimed to leave visitors with a restless sense of insecurity or dissatisfaction, a mental space in which the desire for change might grow.

As Southwark Council was unable to accommodate the debate, we staged a public address on the site of the installation opposite the Town Hall. Paul Gough gave a public address on memorial representations of peace and victory, and explored the history of peace gardens in relation to the Greater London Council during the Cold War.

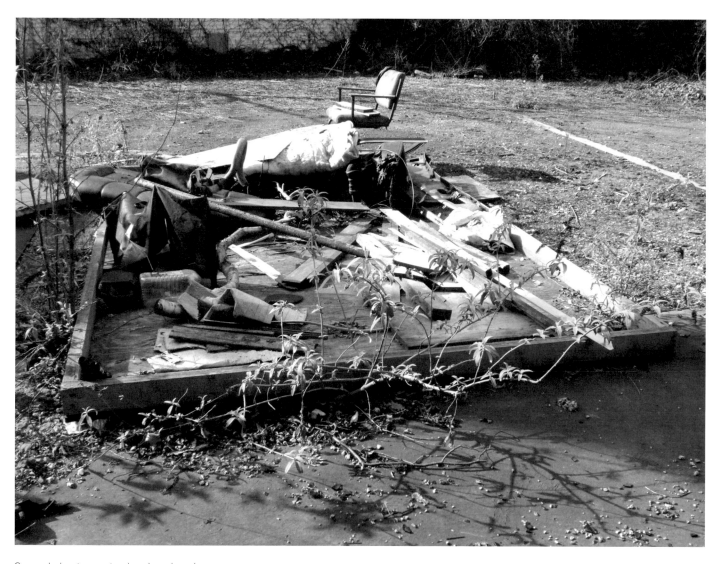

Concealed entrance to abandoned nuclear
bunker, Camberwell, London, 2006

Left:
Entrance to abandoned nuclear bunker
Camberwell, London, 2006

Below:
Air supply system; tinned food; control room;
IBM typewriter; communications hatch

Exit shaft from abandoned
nuclear bunker
Camberwell, London, 2006

Left:
Sealing the bunker entrance

Below left:
Loading the olive tree
Seagrave Nurseries, Leicestershire, England

Below:
Installing the olive tree over the bunker
Photograph by John Timberlake

Paul Gough giving a public address at the
opening of *Words are not Enough*
Camberwell, London, 2007
Photograph by John Timberlake

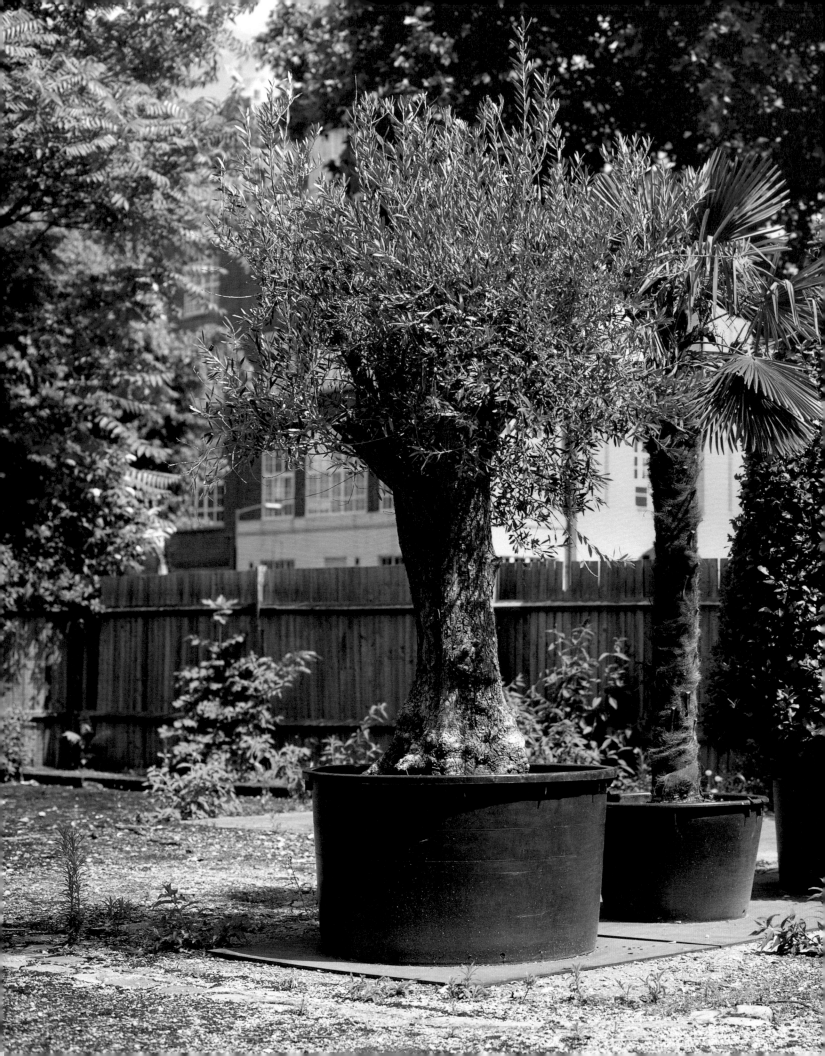

Words are not Enough, 2007
Temporary peace garden
over abandoned nuclear bunker
Camberwell, London

Trance Nation 2007

The year 2007 marked the 40th anniversary of the founding of Milton Keynes, a town remarkable for its combination of urban grid and utopian origins. Sleek corporate head offices line broad avenues whose names evoke the sites or mystic rituals of ancient religion: Silbury, Avebury, Midsummer....

At midnight on the eve of the summer Solstice, a helicopter crew prepared for a flight along a path marking a great logarithmic spiral across the darkened countryside. As the helicopter approached the centre of the spiral, its searchlight fixed on a gathering of Druids and New Age revellers celebrating under the night sky as they awaited the new day.

Two visions arose: the surveillance of the video camera on board the helicopter, counterpointed by the souvenir images captured by the revellers.

Poised between Antonio Gramsci's "pessimism of the intellect and optimism of the will", *Trance Nation* offered a fleeting moment of reflection, as the power of the searchlight was met by the sunlight.

The title *Trance Nation* refers to a genre of dance music marketed by the global media conglomerate Ministry of Sound, owned and controlled by James Palumbo, son of property developer Lord Peter Palumbo.

Peter Hutton
Milton Keynes Leisure Plaza, 2006
Courtesy of Abbeygate Developments Ltd

Above:
Preparing for helicopter flight
Milton Keynes Bowl helipad, England
Dawn to sunrise, 21 June 2007

Right:
View over Milton Keynes from helicopter

Left:
Flight over Willen Park, Milton Keynes

Below:
Summer Solstice gathering
Willen Park, Milton Keynes, England
Dawn to sunrise, 21 June 2007

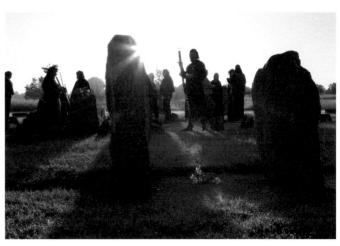

Trance Nation, 2007
Helicopter and searchlight over summer
Solstice gathering
Willen Park, Milton Keynes, England
Dawn to sunrise, 21 June

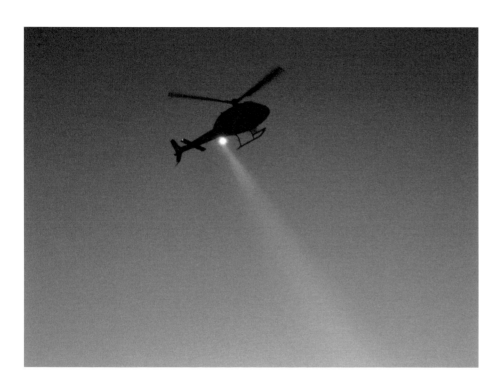

The Abolition of Work 2007

Cornwall is known for its history of copper and tin mining, while Newlyn is famous for its nineteenth-century copper industry. The principal use of copper is as a conduit for water, electricity and telecommunications. The Exchange Gallery, Penzance was once a telephone exchange.

Today's one-penny coin was initially minted in 1971 from bronze, an alloy of copper and tin. It is the lowest denomination of currency in the UK, barely worth picking up. World copper prices rose, making the 'use value' of the metal greater than the exchange value of the coin. By 1992 the penny was worth less than its weight in copper, and the Royal Mint substituted copper-plated steel for the bronze, thus debasing the coin.

We asked for our artists' fee and production budget to be delivered to the gallery in one-penny coins. With a team of helpers, we arranged the coins by hand — heads or tails upward as they came — to cover the gallery floor. The labour of laying the coins did not transform their material properties.

Though the multitude of coins did not represent anything, it resembled many things. The installation can be viewed as a vast puzzle, but one in which all the pieces are the same. The 'picture' formed invites reflection on the definition of labour and the paradoxes of the relationship between art, money, and the value of time.

The Abolition of Work, 1985, is the title of an anarchist pamphlet by Bob Black, who asserts that "work is the source of nearly all the misery in the world" and advocates the complete transformation of society towards a way of life based on play.

Newlyn Tidal Observatory, site of the UK
fundamental benchmark, from which all
heights above mean sea level are based
Newlyn Harbour, England, 2007

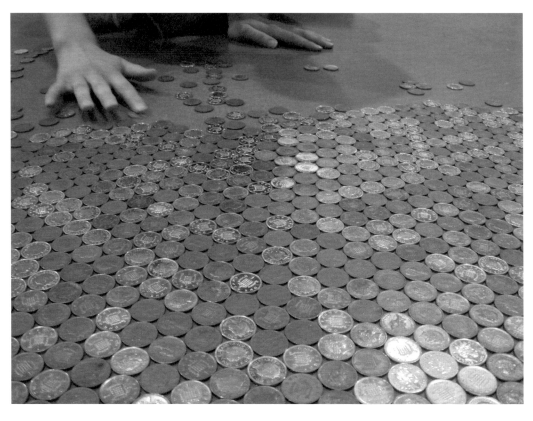

Above and opposite:
Installing *The Abolition of Work* at the
Exchange Gallery, Penzance, England, 2007

Many thanks to volunteers Claire Benson,
Rachel Campbell, Rebecca Griffiths, Ann
Haycock, Louise Hodges, Yasmin Ineson,
Victoria Lingard, Jess Morgan, Jane Pitts,
Judi Rea, Jo Tabone, and Karen Thomas

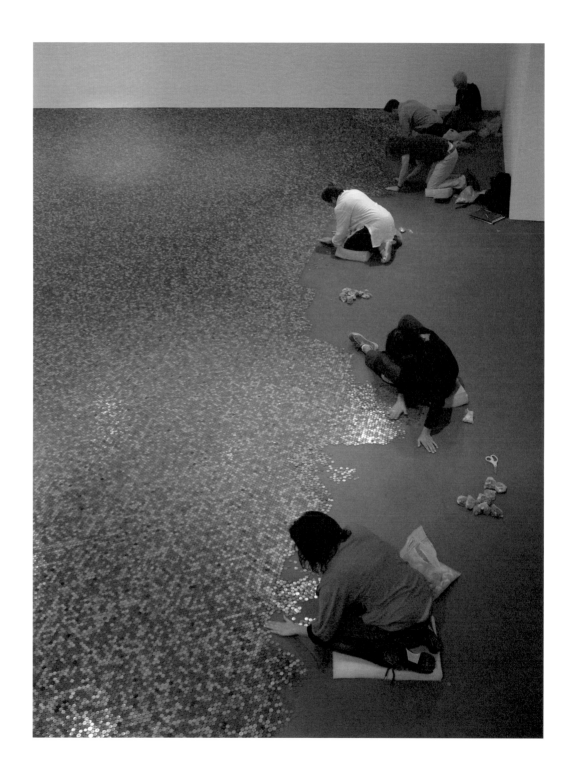

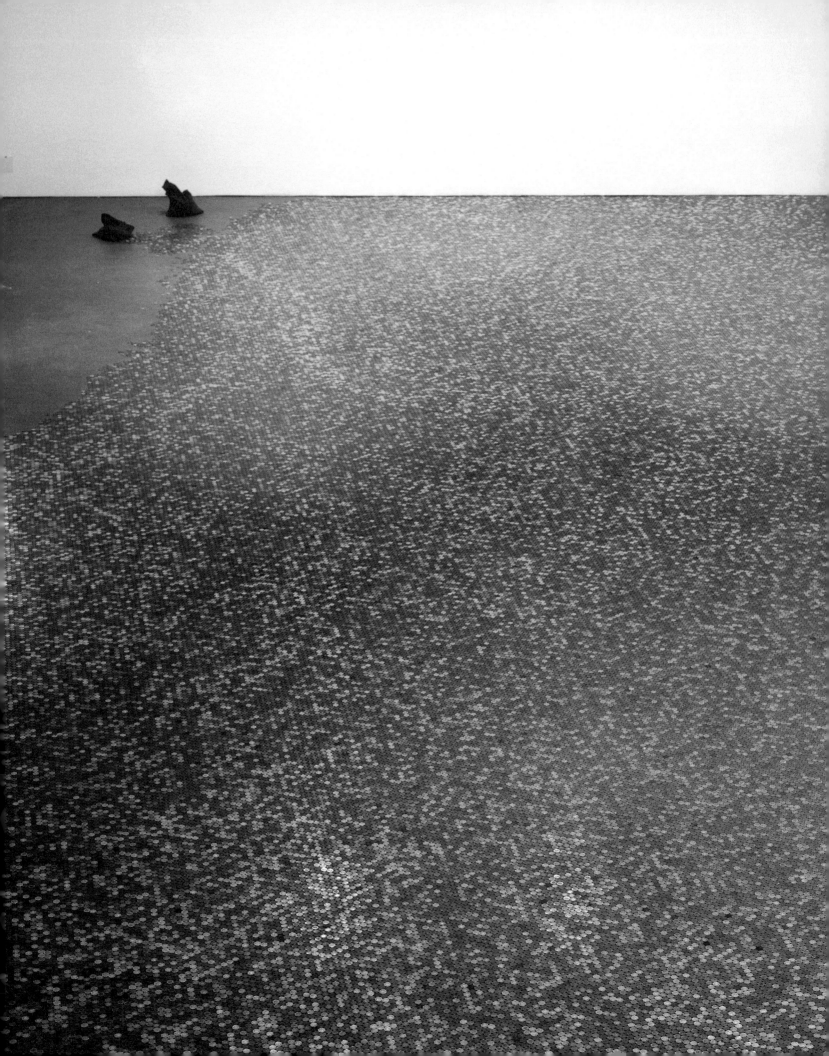

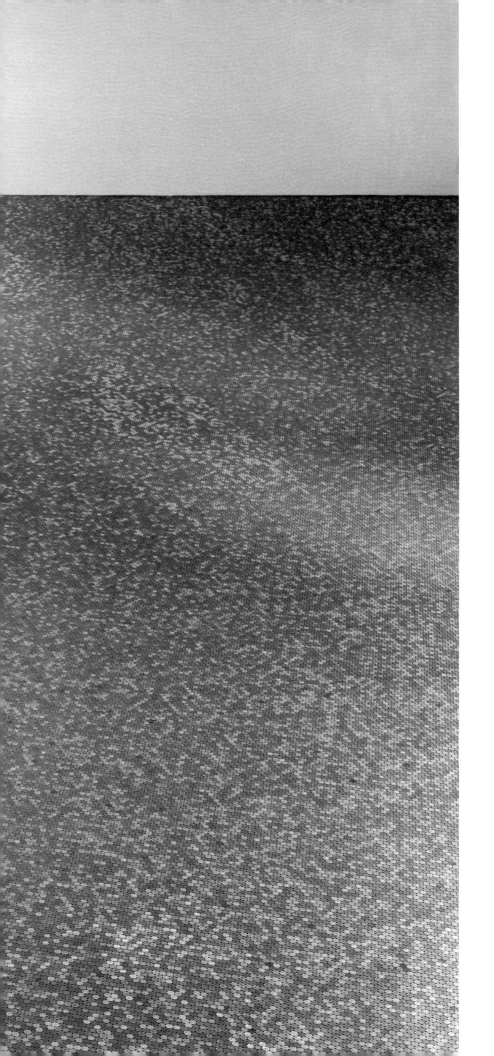

Nearing completion of *The Abolition of Work*
Exchange Gallery, Penzance, England, 2007

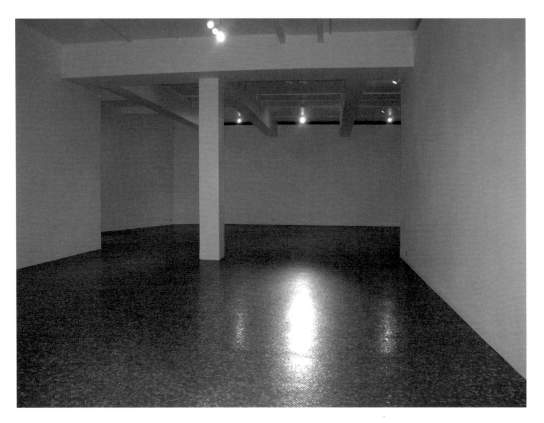

Above:
The Abolition of Work, 2007
Artists' fee and budget in one-penny coins
laid on gallery floor
Exchange Gallery, Penzance, England
Photograph by Isabella Pitisci

Opposite:
The Abolition of Work, 2007

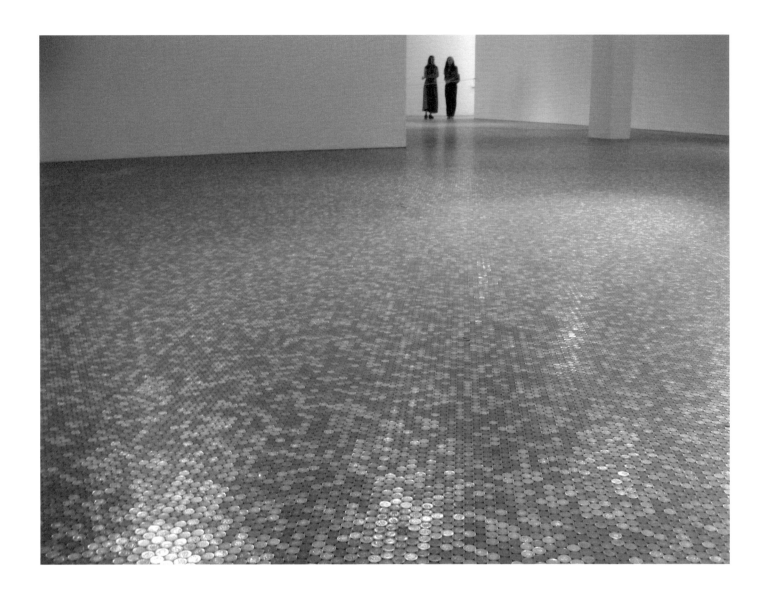

Biography

Cornford & Cross

Matthew Cornford, 1964, Watford, England
David Cross, 1964, Canterbury, England

Matthew Cornford and David Cross began
working jointly while studying at Saint Martin's
School of Art, London, in 1987, and graduated
from the Royal College of Art, London, in 1991.

Selected solo exhibitions and projects

Take My Breath Away
Military, industrial, consumer goods
Curated by Roy Bristow
Metro Cinema, Leicester Square, London
1–28 February 1993

Cultural Exchange
Film canisters, hypodermic syringes, posters
Curated by Marie Odenstrand
Gallery 10 00 22, Stockholm, Sweden
16–29 March 1993

Interpretations
Second World War photographs of Allied night
bombing raids, Calais lace on canvas
Joint exhibition with Dominique Auerbacher
Curated by Leo Stable
Folkestone Library Gallery, Folkestone, England
6 May–6 June 1994

Look Who's Talking
Steel girder, television suspended from ceiling
Curated by Christine Gist
Herbert Read Gallery,
Kent Institute of Art & Design, Canterbury,
England
12 January–10 February 1995

Power to the People
Record collectors' fair in art gallery
Curated by Bryan Biggs
Bluecoat Gallery, Liverpool, England
Saturday 29 March 1997
Catalogue *The Ultimate Mix*

10
Beauty contest judged by facial recognition
software, ten photographs on canvas
Curated by Alison Lloyd
Montage Gallery, Derby, England
28 February–10 May 1998
Catalogue essay by Rosemary Betterton

Cosmopolitan
USA marriage agency interviews with Russian
women, video projection, shipping container
Curated by Irene Nikolai
Nikolai Fine Art, New York, USA
7 September–7 October 2000

Childhood's End
Anarchy symbol drawn by fighter jet in the
sky, shown as two-screen video installation
Commissioned by the Norwich Gallery and
the Mead Gallery, and produced by Film and
Video Umbrella
Curated by Lynda Morris
Norwich Gallery,
Norwich School of Art & Design, England
17 November–15 December 2000
Catalogue essay by Steven Bode

Childhood's End
Anarchy symbol drawn by fighter jet in the
sky, shown as two-screen video installation
Curated by Matthew Shaul
Margaret Harvey Gallery,
University of Hertfordshire, St Albans, England
4 April–18 May 2002

Unrealized Projects 1997–2002
Photographs, scale model, texts on paper
Curated by Mary Jane Aladren
Nylon Gallery, Bethnal Green, London
18 October–17 November 2002

10
Ten photographs on canvas, text on paper
Curated by Scott Rigby
Basekamp Gallery, Philadelphia, USA
6 March–8 April 2003

The Lost Horizon
Computer screensaver of fantasy landscape
generated from financial data
Curated by Ben Eastop
London School of Economics, London
28 May 2003–28 May 2004

Out of Conflict
Childhood's End
Anarchy symbol drawn by fighter jet in the
sky, shown as two-screen video installation
Joint exhibition with Catherine Elwes
Curated by Mark Segal
ArtSway Gallery, Sway, England
8 May–20 June 2004
Catalogue essay by John Timberlake
and Rachel Garfield

Where is the Work?
Photographs, texts on paper
Curated by Alistair Robinson
Northern Gallery for Contemporary Art,
Sunderland, England
24 November 2005–21 January 2006

Fire Down Below
Geometry of gallery doorway outlined in red
silk ribbon
Curated by Joanne Bushnell
Aspex Gallery, Portsmouth, England
24 February–22 April 2007

Where is the Work?
Photographs, texts on paper
Curated by Sandra Ross
Pump House Gallery, Battersea Park, London
6 June–5 August 2007

Words are not Enough
Temporary peace garden over abandoned
nuclear bunker; public address by Paul Gough
Curated by Mark Willsher and Emily Druiff
Camberwell, London
16–24 June 2007

Trance Nation
Helicopter and searchlight over summer
Solstice gathering
Curated by Michael Stanley
Milton Keynes Gallery, Milton Keynes, England
Dawn to sunrise, 21 June 2007

The Abolition of Work
Artists' fee and budget in one-penny coins
laid on gallery floor
Curated by James Green
Exchange Gallery, Penzance, England
29 September–18 November 2007

The Lion and the Unicorn
Maximum safe load of coal laid on gallery floor
Curated by Kate Pryor
Wolverhampton Art Gallery, England
8 November 2008–31 January 2009

Selected group exhibitions and projects

Something Else
Operation Margarine
Paperback book in electric toaster
Exhibition included John Baldessari, Henry
Bond and Richard Long
Curated by David Blamey
Camden Arts Centre, London
22 March–5 May 1996

City Limits
Camelot
Public open space enclosed by steel fencing
Albion Square, Stoke-on-Trent, England
Exhibition included Keith Coventry, Julian Opie
and Beat Streuli
Curated by Godfrey Burke and Terry Shave
University of Staffordshire, England
11–27 September 1996

Across Two Cultures: Digital Dreams 4
Park in the Park
Proposal to convert a city park into a car park
Exhibition included Susan Collins, Gregory
Green and Simon Robertshaw
Curated by Lisa Haskel and Helen Sloan
Newcastle upon Tyne, England
15–17 November 1996

Backpacker
Golden Triangle
Three radios tuned to different stations,
playing in cafes across Chiang Mai City
Exhibition included Fiona Banner, Johnny
Spencer and Richard Wentworth
Curated by Jian Jun Xi and Roman Vasseur
Chiang Mai City, Thailand
1–7 January 1997

East International
New Holland
Steel agricultural structure, sound system
Sainsbury Centre for Visual Arts, Norwich
Exhibition included David Batchelor, Mark
Hosking and Tomoko Takahashi
Selected by Tacita Dean and Nicholas Logsdail
Norwich Gallery,
Norwich School of Art & Design, England
12 July–30 August 1997
Catalogue

October 1917–1997
Cosmopolitan
USA marriage agency interviews with Russian
women, video monitor, headphones
Exhibition included Fiona Banner, Ian Hamilton
Finlay and Mike Nelson
Curated by Lynda Morris
Norwich Gallery,
Norwich School of Art & Design, England
1–25 October 1997

Cap Gemini Art Prize
10
Photographs, text on paper
Exhibition included Jane Prophet, Simon
Robertshaw and Alexa Wright
Judging panel chaired by Charles Esche
Institute for Contemporary Arts, London
11 June–2 July 1998
Catalogue

What Difference Does It Make?
10
Photographs on canvas, text on paper
Exhibition included Art in Ruins, Jeremy
Deadman and Monika Oechsler
Selected by Kate Bush, Matthew Higgs, Olivier
Richon and Ronnie Simpson
Cambridge Darkroom, England
14 June–26 July 1998

International Symposium on Electronic Art
Cosmopolitan
Video projection of USA marriage agency
interviews with Russian women, shipping
container, private security guard and dog
Pierhead, Liverpool, England
Exhibition included Willie Doherty, Judith
Goddard and Keith Piper
Curated by Charles Esche
Manchester and Liverpool, England
2–7 September 1998
Catalogue

East International
Jerusalem
Statue cast from bullet lead, Caen stone plinth
King Edward VI School, Norwich
Exhibition included Bank, Common Culture
and Elizabeth Wright
Selected by Roy Arden and Peter Doig
Norwich Gallery,
Norwich School of Art & Design, England
12 July–28 August 1999
Catalogue

In the Midst of Things
Utopia
Restored ornamental pond, food dye, fountains
Women's Recreation Ground, Bournville
Exhibition included Liam Gillick, Julian Opie
and Lawrence Weiner
Curated by Nigel Prince and Gavin Wade
Bournville, Birmingham, England
2 August–18 September 1999
Catalogue

Let's Get to Work I
Cosmopolitan
USA marriage agency interviews with Russian
women, video monitor, headphones
Exhibition included Ian Dawson, Simon Starling
and Elizabeth Wright
Curated by Gavin Wade and Jonathan van Dyke
Marcel Sitcoske Gallery, San Francisco, USA
1 April–13 May 2000

Utopias
Childhood's End
Anarchy symbol drawn by fighter jet in the
sky, shown as two-screen video installation
Commissioned by the Norwich Gallery and
the Mead Gallery, and produced by Film and
Video Umbrella
Exhibition included Rodney Graham, Matthias
Müller and Mariele Neudecker
Curated by Sarah Shalgosky, Rachael Thomas
Mead Gallery, Warwick University, England
4 October–4 December 2000
Catalogue, essay by Rachel Withers

Look Out
Jerusalem
Photograph on canvas, text on paper
Exhibition included Stuart Brisley, Leon Golub
and Mona Hatoum
Curated by Peter Kennard
Bluecoat Gallery, Liverpool, plus tour
2000–2001
Catalogue

What's Wrong?
The End of Art Theory and *Get Carter*
Unrealised projects, texts on paper
Exhibition included Bank, David Burrows
and Mark Hosking
Curated by Dave Beech
The Trade Apartment, Brixton, London
5 October–5 November 2001

Let's Get to Work II
How Buildings Learn
Gallery doorway blocked by art books
Exhibition included Kathrin Böhm, Atelier van
Lieshout and Sarah Sze
Curated by Gavin Wade and Jonathan van Dyke
Susquehanna Art Museum, Harrisburg, USA
21 July–20 October 2001

Re: mote
New Holland, *Jerusalem* and *Utopia*
Photographs, texts on paper
Exhibition included Alexander and Susan
Maris, Dalziel and Scullion, and Erwin Wurm
Curated by Camilla Jackson
Photographers' Gallery, London
30 November 2001–19 January 2002

Strike
Civilization and its Discontents
Black flag flown from gallery roof
Exhibition included Fiona Banner,
Martin Creed and Jeremy Millar
Curated by Gavin Wade and Liam Gillick
Wolverhampton Art Gallery, England
14 September–9 November 2002
Catalogue

Civic Centre: reclaiming the right to
performance
Cosmopolitan
USA marriage agency interviews with Russian
women, CD players, headphones
Curated by Alan Read
Victoria & Albert Museum, London
15 April 2003

Imaging London
The End of Art Theory
Photographs, text on paper
Exhibition included Tim Brennan, Hadrian
Piggott and Elizabeth Price
Curated by Ben Cranfield
Houldsworth Fine Art, London
17 July–18 August 2003

A Period Eye
A Month in the Country
Stock photographs, whitewash, text on paper
Exhibition with Richard Billingham
and Sarah Jones
Curated by Richard Denyer
Norwich Castle Museum, England
29 September 2003–29 February 2004
Catalogue

Tales of the City
Camelot
Photograph, text on paper
Exhibition included Nils Norman, Abigail
Reynolds and Gary Stevens
Directed by Ann Gallagher
British Council, Artefiera Bologna, Italy
21–26 January 2004
Catalogue

Tonight
The End of History
Text on paper
Exhibition included Adam Chodzco, Liam
Gillick and Andrew Grassie
Curated by Paul O'Neill
Studio Voltaire, London
15 April–30 May 2004

Values: 11th International Biennial of Visual Arts
How Buildings Learn
Doorway blocked by archive material
Civilization and its Discontents
Black flags flown from cultural buildings
Exhibition included Daniel Buren, Jeremy
Deller and Mark Wallinger
Curated by Svetlana Mladenov and Igor Antic
Pancevo, Serbia and Montenegro
29 May–10 July 2004
Catalogue

Perfectly Placed
Where is the Work?
Cast iron floor grille, text on paper
Exhibition included Adam Chodzco, Goshka
Macuga and Paula Roush
Curated by Donna Lynas
South London Gallery
6–29 August 2004

Longitude, Latitude, Season
Childhood's End
Anarchy symbol drawn by fighter jet in the
sky, shown as two-screen video installation
Exhibition included Mark Harris, Robert Moss
and Guillem Ramos Poquí
Curated by Brendan O'Neil
Catalyst Arts, Belfast, Northern Ireland
17 September–9 October 2004

There is Always an Alternative
Christmas Card
Price sticker on gift card, text on paper
Exhibition included Alison Marchant, Hayley
Newman, Giorgio Sadotti
Curated by Dave Beech and Mark Hutchinson
Temporary Contemporary Gallery, London
29 May–10 July 2005
Catalogue

Tra Monti
Why Read The Classics?
Film lamp, reflector on marble statue
Curated by Adrienne Drake, Athéna Panni, and
Maria Rosaria Rinaldi
Tra Monti district, Rome, Italy
15 September–2 October 2005

Obliterated Landscape
A Month in the Country
Stock photographs, whitewash, text on paper
Exhibition included Shezad Dawood, Saron
Hughes and Nikolaj Larsen
Matthew Bown Gallery, London
26 April–26 May 2007

T/raum(a)'68
Unrealized Projects 1997–2002
Photographs, texts on paper
Exhibition included Marcel Broodthaers, Andre
Cadere and Erwin Wurm
Curated by Michel Dewilde, Stef Van Bellingen
Cultuurcentrum, Brugge, Belgium
1 September–7 October 2007
Catalogue

Give Me Shelter
The Once and Future King
Steel security wire over buried well
Attingham Park, Shropshire, England
Exhibition included Henry Krokatsis, Ivan and
Heather Morrison and Keith Wilson
Curated by Anne de Charmant
Meadow Arts, Ludlow, England
27 September 2008–27 September 2009

Bibliography

Selected articles and texts by Cornford & Cross

"Live Adventures"
Chapter for book edited by Iain Borden, Joe Kerr, Alicia Pivaro and Jane Rendell
The Unknown City: Contesting Architecture and Social Space
MIT Press, USA, 2000, pp. 328–339

"Where is the Work?"
Chapter for book edited by Sharon Kivland and Lesley Sanderson
Transmission: Speaking and Listening
Site Gallery and Sheffield Hallam University, 2002, pp. 48–56

"Making History"
Coming up for Air
Prospectus for public monument
Commissioned by Terry Shave
Staffordshire University, England
2002

"Inside Outside"
Article for journal edited by John Roberts and Stephen Wright
Third Text, special issue on collaboration, vol. 18, issue 6, November 2004, pp. 657–665

"Unrealized Projects 1997–2002"
Chapter for book edited by Malcolm Miles
New Practices/New Pedagogies
Taylor & Francis (Routledge), Lisse, The Netherlands, 2005, pp. 53–61

Selected articles and reviews on Cornford & Cross

Julian Rodriguez, "Interpretations"
British Journal of Photography, 18 May 1994, p. 24

Joanna Lowry, "Interpretations"
Creative Camera, October/November 1994, pp. 40–41

Cathy Courtney, "Something Else"
Art Monthly, no. 194, March 1996, pp. 38–39

David Barrett, "City Limits"
Frieze, issue 32, January 1997, p. 74

Alan Read, "No Hiding Place"
Performance Research, vol. 2, issue 3, 1997, pp. 67–68

Rachel Withers, "New Holland"
The Guardian, 23 July 1997, p. 2

Tim Hilton, "The truly East of England show"
Independent on Sunday, 27 July 1997, p. 19

Jacquie Swift, "Public art and public needs"
Journal of the National Association for Fine Art Education, vol. 2, no. 1, 1997, p. 8

Frank Whitford, "The provinces square up to the city"
The Sunday Times, 10 August 1997, p. 8

Sotiris Kyriacou, "East"
Art Monthly, no. 209, September 1997, pp. 37–38

Robert Clark, "10"
The Guardian Guide, 7 March 1998, p. 3

Anna Murphy, "Nobody's perfect"
Observer Life, 23 April 1998, pp. 28–31

Joanna Lowry, "Unnatural selection"
Creative Camera, June - July 1998, pp. 8–11

Mark Hutchinson, "Public Art — oxymoron or what?"
Everything, 2.3, Summer 1998, pp. 40–41

Dave Beech, "What difference does it make?"
Art Monthly, no. 218, July–August 1998, p. 38

Pauline van Mourik Broekman,
"The day the circus came to town"
Mute, issue 12, Autumn 1998, pp. 68–69

John McEwen, "Asses on the rampage"
Sunday Telegraph, 25 July 1999, p. 10

Dave Beech, "East International and Riverside"
Art Monthly, no. 229, September 1999, pp. 21–22

Emma Safe, "In the Midst of Things"
AN magazine, October 1999, p. 20

Mark Beazley, "In the Midst of Things"
Untitled, Autumn 1999, p. 32

Alex Farquharson, 'In the Midst of Things'
Frieze, issue 49, November–December 1999, pp. 96–98

Gavin Wade, "Cornford & Cross and Elizabeth Wright"
art/text, no. 68, February–April 2000, p. 93

Yevgegny Fiks, "Cosmopolitan"
Moscow Art Journal, no. 36, Spring 2000, pp. 91–92

Gavin Wade, "Wishful Thinking"
Untitled, Spring 2000, pp. 22–24

Duncan McLaren, "In the Midst of Things"
Zing, issue 12, 2000, pp. 220–222

Joanna Pitman, "… but they know what they like"
The Times Magazine, 8 July 2000, p. 32

Dave Beech, "Public Art after virtue"
Public Art Journal, vol. 1, no. 3, 2000, pp. 26–31

JJ Charlesworth, "The Art of the Third Way"
Art Monthly, no. 241, November 2000, pp. 9–10

Richard Hylton, "Look Out"
Art Monthly, no. 241, November 2000, pp. 24–25

Maria Walsh, "Utopias"
Art Monthly, no. 241, November 2000, p. 32

Carly Berwick, "Upwardly mobile"
Artnews, vol. 99, no. 11, December 2000,
p. 42

Nigel Wilson, "Childhood's End"
Flux, issue 22, December 2000–January 2001,
pp. 50–51

Stephen Coates and Alex Stetter
*Impossible Worlds: The Architecture of
Perfection*
August, London/Birkhäuser, Basel,
2000, pp. 96–97

Gavin Wade, "In the Midst of Things"
La Ville, le Jardin, la Mémoire
Académie de France à Rome, Villa Médicis,
Rome. 2000, p. 82

Henrik Schrat and Oliver Hartung,
"The picture as index of lived experience"
4.28, no. I, 2001, pp. 9–12

Adrian Kear, "Parasites"
Parallax, vol. 7 no. 2, 2001, pp. 31–46

Lisa Lefeuvre, "Heart of Glass"
Katalog, vol. 14 no. 1, 2002, pp. 48–49

Robert Clark, "Childhood's End"
The Guardian Guide, 19 October 2002, p. 35

Alicia Miller, "Trails of the unexpected'
ArtReview, vol. LIII, October 2002,
pp. 102–103

Mark Currah, "Cornford & Cross"
Time Out, 30 October–6 November 2002,
p. 57

Dave Beech, 'Cornford & Cross'
Art Monthly, no. 262, December 2002, front
cover and pp. 23–24

Rachel Withers, "Cornford & Cross"
Artforum, vol. XLI, no. 5, January 2003,
pp. 149–150

Laura Chiari, "Artisti, attivisti!"
Next Exit, Rome, Italy, no. 19, June 2004

Tom Lubbock, "Five Best Shows in London"
The Independent, 19 August 2004

Malcolm Miles,
Urban Avant-Gardes: Art, Architecture and Change
Routledge, London, 2004, pp. 166–169

Malcolm Miles, "Interruptions: Testing the
Rhetoric of Culturally Led Urban Development"
Urban Studies, vol. 42, nos 5/6, May 2005,
p. 905

Jane Rendell
Art and Architecture: A Place Between
IB Tauris, London, 2006
pp. 44–45, 105–107

Sandra Rehme, "Obliterated Landscape"
Time Out, 9–15 May 2007, p. 41

Statue of Lenin, VDNKh Park, Moscow, 1998

Acknowledgements

We would like to thank Alistair Robinson, Programme Director of the Northern Gallery for Contemporary Art, for initiating this book and Arts Council England touring exhibition. Our thanks also go to Joanne Bushnell, Director of Aspex Gallery, and Elizabeth Knowles, then Director of Newlyn Art Gallery, for the vital commitment they gave the project in its early stages. We are especially grateful to John Roberts and Rachel Withers for the insightful and critical essays that they have written for this book.

Our interventions are often disruptive to everyday life, so realising them calls for close interaction with the people who occupy places and influence events. Every art project we have carried out has encountered obstacles, which were only overcome with the flexibility shown by people who have been prepared to take risks, go beyond conventional interpretations of their roles and become active participants.

For their longstanding support and investment in our practice, we thank Dave Beech, Daniel Brooke, Malcolm Miles, Lynda Morris, John Timberlake, and Gavin Wade.

For the opportunities they have allowed us at key moments in our career, we thank Mary Jane Aladren, Bryan Biggs, Steven Bode, Iain Borden, Dan Fern, Bronac Ferran, Simon Kirby, Irene Nikolai, Sarah Shalgosky, and Terry Shave.

For their special contribution to particular projects, we thank Igor Antic, Kate Brindley, Mary Doyle, Robert Eagle, Ben Eastop, Stephen Emmot, Robert Grose, Margot Heller, Milan Jacsic, Nicola Johnson, Mike Jones, Martin Lefley, Donna Lynas, Svetlana Mladenov, Nigel Prince, Kate Pryor, Alan Read, Matthew Shaul, Leo Stable, Michael Stanley, Blair Todd, Neil Tudman, Paige West and Simon Willmoth.

Matthew Cornford:
My thanks to Andrew Brewerton, Bryony Conway, Keith Cummings, Jean Gilkison and Antonia Payne of the University of Wolverhampton for their valuable support. Thanks also to John Beck, John Crick, Mark Davies, Matthew Hobson, David Ladbury, John Trice and Nigel Tudman for friendship, conversation and advice. For her encouragement, companionship and love, my special thanks are due to Isabella Pitisci.

David Cross:
My thanks to Oriana Baddeley, Paul Coldwell, and Chris Wainwright at the University of the Arts London for their valuable support. My personal thanks are due to David Blamey, Bart Coles, Peter Kavanagh, Dermot Reilly and Trevor Varley for the generous support they have given over the years. Jane Rendell is outstanding for all the help, advice, encouragement and affection she has given me over the years, and also for her professional contribution to my work and this book.